Wildflower WATERCOLOUR

Recognising and Painting Nature

Gaëtane Nicoulin-Béchir

HOAKI

HOAKI

Hoaki Books, S.L.
C/ Ausiàs March, 128
08013 Barcelona, Spain
T. 0034 935 952 283
F. 0034 932 654 883
info@hoaki.com
www.hoaki.com
hoakibooks

Wildflower Watercolour
Recognising and Painting Nature

ISBN: 978-84-19220-75-2

Author: Gaëtane Nicoulin-Béchir
Translated by Emma Sayers
Editor: Ricardo Rendón
Cover design: Carla Gasparrini

The author and publisher have carefully compiled all the information
required to produce the artwork and accept no responsibility for any
errors or for the rendering of the works presented.

D.L: B 6293-2024
Printed in China

Contents

5 Preface

6 Foreword

7 **The essentials of watercolour painting**
7 Equipment
11 Additional equipment
12 Colour theory

18 **The best techniques**
18 Water management
19 There are three main watercolour techniques
20 Different ways to hold your brush
24 Gradients
24 Washes
25 Textures
26 The preparatory sketch
26 Correcting mistakes

27 **Painting wildflowers**
27 The anatomy of a flower and a leaf
28 How to simplify a flower
33 How to paint white flowers

34 **Creating an inspiring herbarium**
34 A natural herbarium
35 A painted herbarium

36 **How to organise your creative workspace**

37 **20 flowers to paint**
38 Rosehip
42 Fireweed
46 Sainfoin
50 Red Clover
54 Red Campion
58 Poppies
62 Snake's Head Fritillary
66 Common Comfrey
70 Common Mallow
74 Field Scabious
78 Harebell
82 Woodland Geranium
86 Water Avens
90 St. John's Wort
94 Dandelion
98 Buttercups
102 Chamomile
106 Ribwort Plantain
110 Meadowsweet
114 Black Elderberry

118 **Floral Composition**
118 The protected home

120 **Acknowledgements Supplies Bibliography**

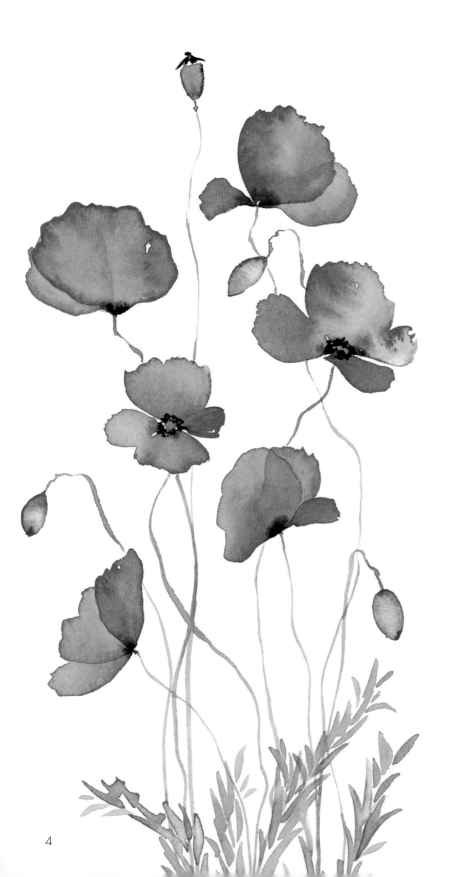

Preface

Gaëtane's work takes you into a world of delicacy and poetry. I've always been struck by the care and sensitivity that emanates from her work, which accurately captures the gentle fragility of plants. I love how her creations, like a dance on paper, capture the slender elegance of the stems and the transparency of the petals that have as many fusions as the flowers have subtle nuances.

What is particularly striking about Gaëtane's artwork is that it is not a florist's elaborate bouquet with an intricate array of petals that attracts attention. Rather, it is the very simplicity of a wild herb or the elegance of blades of grass that appeals to the eye. By sharing her passion with us, Gaëtane encourages us to take a fresh look at the richness of the plant world. Modest, understated specimens take centre stage and reveal new creative avenues.

With this book, not only will you discover new techniques for painting plants, you will also get to know the person holding the brush. Over the years, I've become a little more acquainted with Gaëtane, and through these pages, you'll understand how she sees nature and how it fuels her art. Gaëtane makes plants come to life and tell stories, poems even. Not just flowers and leaves, but branches, roots and bark also have secrets to reveal to us. By taking a close look at them, we can draw inspiration from their shapes, colours, and the patterns they make together. We are also invited to go further and marvel at their gastronomic potential, as well as their therapeutic and tinting properties.

In addition to inspiring you to paint, this book is an ode to the unspoilt nature that surrounds us. Next time you go for a walk, you'll be enchanted by all the tiny intertwined and coiled stems, the delicate little flowers, and you'll be able to incorporate berries and seeds sown by the wind into your future creations. This philosophy also applies to Gaëtane's teaching methods. In the book, we are encouraged to approach our art with sensitivity and concentration, much like we would observe nature. In the words of the author, "Like a plant that you water and patiently watch as it grows and flourishes, look on with the same loving kindness as your watercolour painting comes to life."

Let's allow ourselves to be guided by the illustrations, compositions and step-by-step instructions herein, so that we may add to our creations a touch of romanticism and wild poetry.

Marie Boudon,
founder of tribulationsdemarie.com

Foreword

Gaëtane's watercolours are instantly recognisable. Painted in delightfully old-world colours, her plants and flowers tell the story of the natural world she admires every day. Trained as a chemistry laboratory technician, Gaëtane's interest in plants has inspired her imagination since she was very young. As a child, she grew up in a particularly verdant region of Switzerland. Her mother, and her grandmother before her, would gather and use wild plants to make herbal remedies and delicious, aromatic dishes.

For her, painting nature is like rediscovering some of those memories. It's also a way for her to reveal this fragile beauty, to celebrate it and show just how much it deserves to be preserved.

This book is an invitation to go looking for these wildflowers, the ones we come across while on a walk or see emerging in gardens in springtime. Their diaphanous petals and subtle hues provide inexhaustible subject matter for a watercolourist.

Gaëtane explains essential watercolour painting techniques and shares her tricks of the trade before transporting us into the world of wildflowers. She teaches us to observe the specific anatomical features of each one. Then, step by step, she guides us through the process of painting them, developing our creative intuition. This is the starting point for finding one's own style.

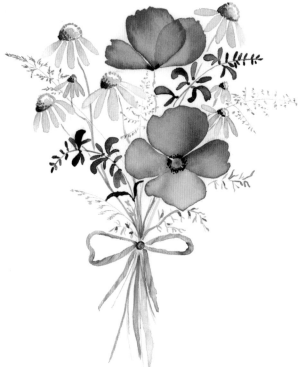

The essentials of watercolour painting

Equipment

THE IMPORTANCE OF PAPER

Touching the paper, caress it, really get a feel for it. Paper is the substrate on which you will paint your future watercolour paintings. Don't underestimate the importance of working on good quality paper; it is the pillar on which your future watercolours rest. Using blunt brushes or slightly chalky paints is fine; as long as the paper is good quality, you'll get a good result. On the other hand, if you use expert materials to paint onto photocopier paper... what a shame!

For watercolour paintings, the paper has to be thick. The weight of a sheet of watercolour paper is usually 300 g/m²; it can absorb a lot of water without buckling too much.

There are two main types of paper that are specifically made for watercolour painting:

- **Cellulose paper**
- **Cotton paper**

You'll find 100% cellulose paper, 25% or 50% cotton blends and 100% cotton paper on the market. Cellulose paper is the most affordable; I recommend it for beginners, colour tests or brushstroke practice. Cotton paper, on the other hand, is better for working with wet paint. Although it can be more difficult to correct mistakes, colours come out beautifully vivid and the fusion of pigments is incomparable. These papers come in several different finishes:

- **Hot pressed** (*grain satiné* in French) is the smallest grain and has a very smooth texture. It is ideal for highly detailed watercolours and portraits. This paper is a particularly good choice if you also use watercolour pencils or Neocolor watercolour wax crayons;
- **Cold pressed** (*grain fin* in French) is a medium grain paper. **Its texture is a good compromise**: neither too rough nor too smooth. It is suitable for all watercolour techniques;
- **Rough grain** (*grain torchon* in French) is the most textured paper. It is very bumpy, making it unsuitable for detailed artwork. That said, it is particularly good for landscapes and allows you to create textured and relief effects.

As you can appreciate, it's also a question of taste. I encourage you to try as many as possible. Some shops and websites offer samples. Or, better still, talk to other watercolourists about their experiences. The creative Instagram community is caring and supportive.

Watercolour paper can be purchased in a notepad or notebook, as individual sheets or in rolls. It's best to start off with a notepad. Later, once you've decided on a particular brand and texture, it is more economical to buy it in large sheets (56 x 76 cm) and cut as required.

All the watercolour paintings in this book have been painted on 100% cotton paper. I encourage you to switch to this type of paper as soon as possible.

To start wtih cellulose paper it's certainly better, and it's important to always have some on hand. Some artists only work on this type of paper, especially if they combine techniques.

Again, it's a matter of taste. But if you want to use a lot of water, or work on blends and shading, painting onto 100% cotton paper is much more rewarding. For my part, I waited far too long and it wasn't until I took the plunge and switched to cotton paper that I really started to evolve. That's why I encourage you to use this kind of paper as soon as possible.

BRUSHES

Paintbrushes come in a multitude of different forms: round, wash, flat, oval, fan, water brush, etc.

Anatomy of a paintbrush

First of all, to explain things better, a paintbrush is made up of three parts:

- The bristles
- The ferrule
- The handle

The **bristles (1)** can be made of synthetic hair or natural hair (petit-gris, marten, mongoose, goat, etc.) It is divided into two parts: the fine tip and the belly, which can soak up water and retain pigments. As such, it becomes a reservoir of watercolour paint.

The **ferrule (2)** can be cylindrical or flat, metal (brass) or plastic. The bristles are glued to the inside of the ferrule with synthetic resin.

Finally, the **handle (3)** is usually made of a soft wood, such as beech, ash or birch. Plastic handles are also available.

My favourite paper brands

I've long been a fan of **Fabriano**, and these two papers have all the plus points I look for, in addition to excellent value for money:

- *100% Fabriano Artistico cotton – 330g/m² – fine grain – extra white – 23 x 30.5 cm block and "jésus" format 56 x 76 cm.*

 A well as its texture, I particularly like how strong it is.
 It can withstand rubbing out, corrections and the application of masking fluid, unlike other, more fragile paper brands. I use both sides.

- *Cellulose Fabriano START – 240g/m² – drawing paper – 21 x 29.7 cm pack.*

 Given its low cost, I have no qualms about using it for colour tests, movement tests or drafts.

What makes a good brush?

A good brush is one that you enjoy using, one that feels like an extension of your hand and is perfectly suited to the way you paint. But, above all, it doesn't lose its bristles!

You can find some top-brand watercolour brushes on the market that, although they are made with top-quality bristles, you hate them anyway.

And then there are others that just feel right, brushes that give you a feeling that rings out like a beautiful melody. So-called best quality brushes, or brushes that cost the most money, will not necessarily guarantee a pleasant experience, because everyone has their own way of painting.

The way you hold your brush also influences the type of handle you choose: smooth or non-slip, long or short, thick or thin. **For my part, I hold my brush in two different ways:**

- When I paint very spontaneously and imprecisely, or when I want to make sweeping brushstrokes, I hold my brush at the top of the handle. That way, I have more flexibility and avoid making any jerking movements on a long brushstroke, for example.

1

2

3

So I like a nice long and lightweight handle.
- Conversely, when I work on details, I hold the ferrule, keeping my brush upright. In this case, a short brush is more suitable.

Taking care of your brushes
Three golden rules:

- Never leave a brush sitting in a pot of water.
- Rinse your brushes thoroughly at the end of each painting session.
- Dry brushes lying flat.

All it takes is a few simple steps to protect your brushes. When painting, do not leave the brushes in your water pot. Rinse them and lay them flat on a brush rest, your palette or a cloth. If you immerse brushes in water for too long, the liquid may seep into the ferrule and break down the glue that holds the bristles together. Water can also cause wooden handles to swell and split, making the varnish peel off.

At the end of your watercolour painting session, always rinse used brushes thoroughly with clean water. Drain excess water by stroking the bristles against the rim of the pot, then dabbing them on a cloth. Take the opportunity to reshape the tips of your brushes between your thumb and forefinger. After that, let your brushes dry flat. Check that there is nothing between the bristles that could cause them to form a crease. Once your brushes are nice and dry, you can store them upright again.

From time to time, I clean them a little more thoroughly by rubbing the bristles in the palm of my hand, where I've first applied a little mild soap. Simply lather the bristles in a circular motion, then rinse them thoroughly with cold water. Hot water could damage the bristles on your brushes.

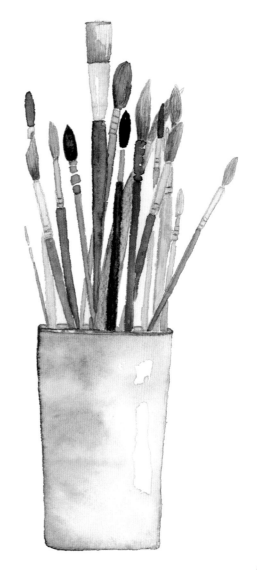

My favourite brushes

I usually paint with round brushes made of synthetic hair. The ones I use on a daily basis are called **Schimoni Art by Fibonacci**.

I used three brushes (one small, one medium and one large) to paint all the wildflower illustrations in this book:

- *Small fine brush: All-Rounder n°4 (or Mini-Quill n°0.1),*
- *Medium round brush: All-Rounder n°.6,*
- *Large soft brush: Soft Quill Brush n°1.*

Fibonacci brushes are handcrafted and can be quite challenging for someone who has never done watercolour painting before. So if you are a novice, I would recommend using the da Vinci brand instead:

- *Small fine brush: Nova n°2,*
- *Medium brush: Nova n°6,*
- *Large soft brush: Colineo 5522 n°8 (or Casaneo n°2).*

WATERCOLOUR PAINT

The first thing to remember is that there are two types of watercolour paint: **fine and extra-fine.**

The main differences are the concentration of the pigments and the quality of the binders used. And this applies to all brands. When you are starting out, fine watercolour paint is good enough. But if you find you like watercolour painting and need to replace your colours, give extra-fine a whirl. It costs a tad more, but the result is much more homogenous, vibrant and therefore more impressive.

Watercolour paints are mainly sold in pans (dry) or tubes (paste).

The pigments are ground to a very fine powder using stone wheels that turn slowly so as not to heat up the paste. Gum arabic (sap from the Senegalese acacia tree) and sometimes honey are added, depending on the quality, and glycerine is added for watercolours sold in tubes.

The pigments used can be of different origins:

- **Mineral:** extraction and grinding of minerals, eg. raw Siena, raw umber = PBr7 = natural brown iron oxide.
- **Organic:** chemical compounds, eg. azomethine yellow green = PY129 = azomethine copper complex.
- **Animal:** such as carmine = NR4 = cochineal beetles.
- **Plant:** such as genuine madder lacquer = NR9 = madder root.

If you want to go even further, check out the **Colour Index International**. This is a very interesting international system for naming the pigments and colourants used in all types of paint. This classification system is based on a colour and a number related to the pigment's chemical composition. As it was originally designed in the United States, the abbreviations are in English. You can easily find the full list on the Internet by searching "**List of colors**" (pigments). Below is the list of abbreviations.

And if, as is the case with Vandyck brown, you read two abbreviations (PR101 and PBk7), it simply means that this colour is the result of mixing two pigments together.

P = synthetic pigment +

N = natural +

W	= white
Y	= yellow
O	= orange
R	= red
V	= violet
B	= blue
G	= green
Br	= brown
Bk	= black

Example:
Pink quinacridone **PV19**
= synthetic pigment/ purple / n°19

Taking a closer look at your tube or palette packaging, you will also find other valuable information:

- Light resistance
 +++ 100 years minimum
 ++ 25-100 years

- Transparency:

Transparent Semi-transparent Semi-opaque Opaque

- Texture:
G = colours that granulate, like those shown below.

Twilight yellow

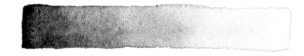

Cobalt blue

My favourite paints

- *Extra-fine quality*

I really like the **Rembrandt** brand because of their excellent range of colours, the quality of their pigments and their creamy consistency. They're really easy to reactivate.
I usually order half pans of them. I order tubes of the colours I use more frequently, so that I can top up my half pans whenever I need to. Just let it dry off for a few days in a dust-free environment, and it will be ready to use. You will find my ideal basic palette on pages 16-17.

- *Handmade watercolour paints*

You can also find more sophisticated watercolour paints on the market, such as those made traditionally by hand. I particularly like **"Les Couleurs VF"**. These two Charente artists are dedicated to creating dazzling colours. The pigments are ground by hand using a pigment binder and each pan is filled in several stages. As a lover of pink, I like to expand my basic palette with more sophisticated shades, including pink flamingo, Royal Ann cherry, coral, rosewood, peony and so on.

Additional equipment

WATER POTS

To rinse my brushes, I like to have two pots of water on hand:

- one is a large transparent glass jar, so that I can check the colour of the water and renew it as necessary.
- the other is smaller – the one I use is ceramic – which always has clean water in it. I use it to quickly erase splashes, correct a brushstroke or lighten an area with a drop of water.

CLOTH

An old piece of cloth (or a large wipe), but folded flat rather than scrunched into a ball. It serves several purposes:

- to regularly give the brush a wipe.
- to regulate the amount of water in the bristles.
- to absorb the overflow of pigments loaded into the brush.

TISSUES

You need to have some on hand at all times to quickly mitigate an accident, a splash or absorb an overly pigmented surface.

A PENCIL

I use a 0.5 mechanical pencil with HB lead. It is good for light sketches and details. The metal tip can also be used to scratch painted surfaces.

ERASERS

A standard white, rectangular eraser will do the trick. I cut it lengthwise so I can be more precise when rubbing something out. I also use a kneaded eraser to soften lines I have drawn. It has the advantage of leaving no residue.

MASKING TAPE

I find rolls of DIY masking tape very economical and practical. However, make sure you remove some of its stickiness by rubbing it on your clothes before you use it, to avoid tearing the paper.

MASKING FLUID

This can be used when you want to leave an area of the paper white. I only use silicone brushes, skewer picks or toothpicks to apply it, so as not to damage the bristles of a brush.

Of all the liquids I've tested, Liquid Masking Film by **Talens** is my favourite. It is visible but doesn't stain the paper, and can easily be removed.

A RULER AND
A PAIR OF COMPASSES

These two tools can often prove to be indispensable for measuring and drawing straight lines, or drawing perfect arcs and circles.

Tertiary colours

Tertiary colours are created by a mixture of a primary colour and a secondary colour.

A PIPETTE

It's handy to have a bottle of water with a collection pipette so you can add a drop in each paint pan, allowing the pigments to reactivate after a few seconds.

A LAMP

That's a great list of very useful materials, but the most important thing is being able to see well. If you paint during the day, you will rarely encounter any problems. But if, like me, your creative sessions take place mainly at the end of the day or in the evening, excellent lighting is essential. Fortunately, these days there are lamps that have been specially designed to give artists what they are looking for. I use the **BenQ WiTdesk** lamp. As well as providing plenty of light, it has the advantage of rendering colours exactly as they look in daylight.

Colour theory

COLOUR WHEEL

The colour wheel makes it easy to identify and understand colours. Just choose two colours opposite each other to create the perfect combination of warm and cool.

Primary colours

There are three primary colours: magenta red, cyan blue, and primary yellow. These three colours cannot be obtained by mixing other colours. However, by mixing them together, we obtain every colour possible.

Secondary colours

There are three secondary colours: purple, green and orange. They are a mixture of two primary colours in equal parts.

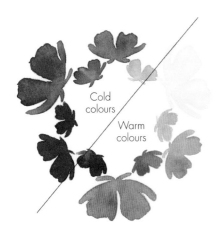

THE TEMPERATURE OF COLOURS

Colours close to **blue** on the colour wheel are considered to be **cold**.

Colours close to **red** on the colour wheel are considered to be **warm**.

A MONOCHROME COMPOSITION

This is the use of all shades of a single colour.

→

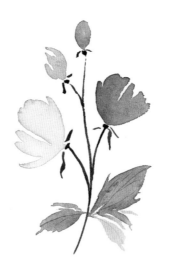

AN ANALOGOUS COMPOSITION

This involves combining similar colours, i.e. three colours that follow on from each other on the colour wheel, together with all their declinations (mixture, intensity, dilution).

→

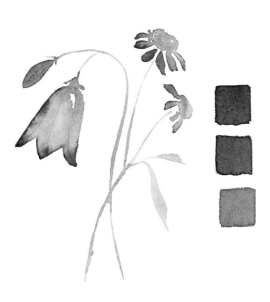

COMPLEMENTARY COLOURS

This is the combination of two colours that are diametrically opposed on the colour wheel. For example, red and green or orange and blue.

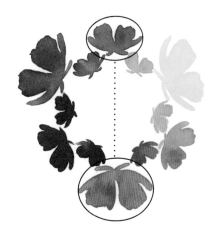

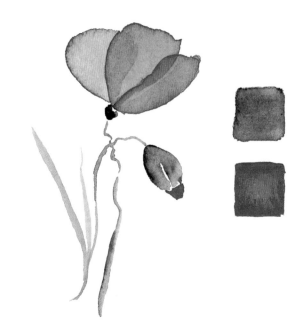

COLOUR VALUES

The value denotes how bright a colour is. It refers to how dark or light a colour is compared to black or white.

This scale of values is used as a reference, with black having a value of 1 and white having a value of 10. For example, a dark shade like Payne's grey has a value that is close to black. Starting from the pure colour directly from the pan and gradually diluting it, you can make 10 squares. The scale therefore ranges from 1 to 10.

Note that this is not an exact science. Over time, you will learn how much water to add to obtain such a wide range of shades.

For yellow ochre, on the other hand, if you apply the colour directly from the pan, saturating the first square, you can only make a maximum of 6 squares. The scale therefore ranges from 5 to 10.

SATURATION OR INTENSITY

Saturation pertains to how intense a colour is; it can also be referred to as the "purity" of a colour. It relates to the concentration of pigments: the purer the pigment, the more saturated and intense the colour is. A colour can be desaturated by mixing it with other, more neutral shades of grey, black or dark brown.

COLOUR BLENDS

In order to visualise the wide range of ways in which the colours in my palette can be mixed together, I made a mixture book that presents each colour in my basic palette. The task may seem tedious, but it's a good way to have the mixtures arranged in a clear and practical way. I always have this notebook close to hand so that I can refer to these colour combinations when I am painting.

Opposite, the dark azo yellow page. I'm not particularly keen on orange, but I was able to discover some really beautiful hues with these mixture tests. For example, let's look at the 4th line of the colour chart opposite, the dark azo yellow has been mixed with quinacridone pink.

The first rectangle:
lots of dark azo yellow +
a little quinacridone pink.

The second rectangle:
a little dark azo yellow +
a lot of quinacridone pink.

With these two concentrations, I can achieve a range of possible shades between these two pure colours. This leads to some rather unexpected hues.

I can't recommend this exercise enough.

And of course, we're only talking about the combination of two colours here. Imagine the endless possibilities when you combine three or more colours!

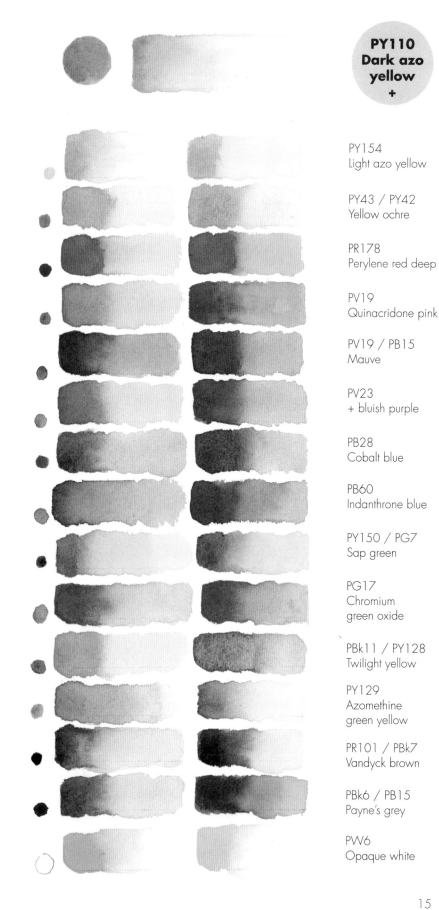

**PY110
Dark azo
yellow
+**

PY154
Light azo yellow

PY43 / PY42
Yellow ochre

PR178
Perylene red deep

PV19
Quinacridone pink

PV19 / PB15
Mauve

PV23
+ bluish purple

PB28
Cobalt blue

PB60
Indanthrone blue

PY150 / PG7
Sap green

PG17
Chromium
green oxide

PBk11 / PY128
Twilight yellow

PY129
Azomethine
green yellow

PR101 / PBk7
Vandyck brown

PBk6 / PB15
Payne's grey

PW6
Opaque white

MY BASIC PALETTE

This is my ideal palette: colours with great potential, vibrant shades and a starting point for a wide range of blends. To complement these 15 colours, it is useful to include opaque white PW6. Use diluted to create velvety shades, or in higher concentrations to create more opaque colours.

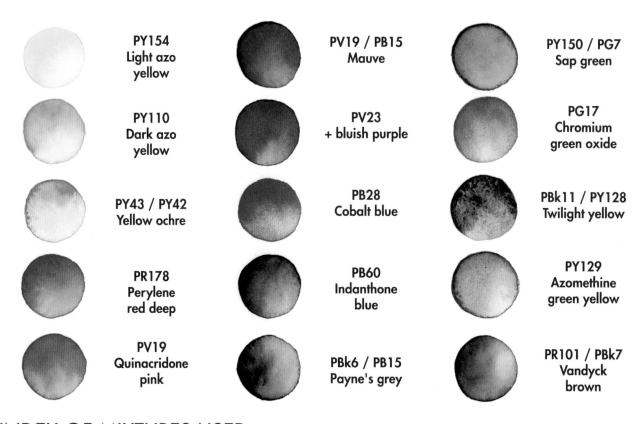

PY154
Light azo yellow

PY110
Dark azo yellow

PY43 / PY42
Yellow ochre

PR178
Perylene red deep

PV19
Quinacridone pink

PV19 / PB15
Mauve

PV23
+ bluish purple

PB28
Cobalt blue

PB60
Indanthone blue

PBk6 / PB15
Payne's grey

PY150 / PG7
Sap green

PG17
Chromium green oxide

PBk11 / PY128
Twilight yellow

PY129
Azomethine green yellow

PR101 / PBk7
Vandyck brown

INDEX OF MIXTURES USED IN THIS BOOK

These blends and their names come straight from my imagination.

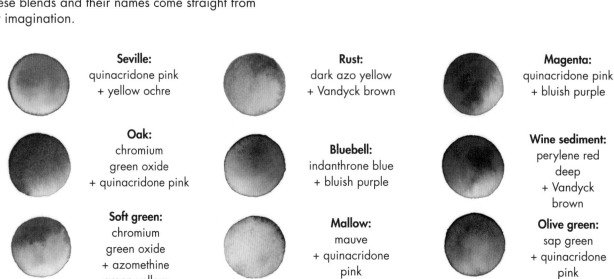

Seville:
quinacridone pink + yellow ochre

Oak:
chromium green oxide + quinacridone pink

Soft green:
chromium green oxide + azomethine green yellow

Rust:
dark azo yellow + Vandyck brown

Bluebell:
indanthrone blue + bluish purple

Mallow:
mauve + quinacridone pink

Magenta:
quinacridone pink + bluish purple

Wine sediment:
perylene red deep + Vandyck brown

Olive green:
sap green + quinacridone pink

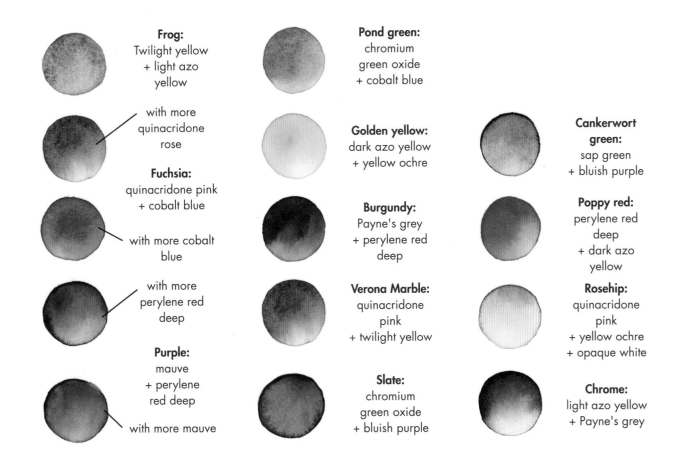

Frog:
Twilight yellow
+ light azo
yellow

with more
quinacridone
rose

Fuchsia:
quinacridone pink
+ cobalt blue

with more cobalt
blue

with more
perylene red
deep

Purple:
mauve
+ perylene
red deep

with more mauve

Pond green:
chromium
green oxide
+ cobalt blue

Golden yellow:
dark azo yellow
+ yellow ochre

Burgundy:
Payne's grey
+ perylene red
deep

Verona Marble:
quinacridone
pink
+ twilight yellow

Slate:
chromium
green oxide
+ bluish purple

**Cankerwort
green:**
sap green
+ bluish purple

Poppy red:
perylene red
deep
+ dark azo
yellow

Rosehip:
quinacridone
pink
+ yellow ochre
+ opaque white

Chrome:
light azo yellow
+ Payne's grey

DESATURATED COLOURS

In my freestyle compositions, I particularly like to use mixtures of desaturated colours. I use neutral shades like Vandyck brown, Payne's grey, and twilight yellow.

These colours give a slightly "aged" effect to the pure colours, something I really love. Here are some examples of desaturated mixtures and how they turn out.

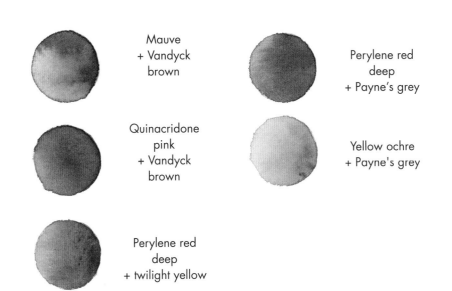

Mauve
+ Vandyck
brown

Quinacridone
pink
+ Vandyck
brown

Perylene red
deep
+ twilight yellow

Perylene red
deep
+ Payne's grey

Yellow ochre
+ Payne's grey

The best techniques

Water management

Water is the main ingredient in watercolour paint, and learning how to manage how much water you need to use is essential. Once you've done that, you'll have mastered most of the technique. Above all, don't give up hope; take pride in the enjoyable experience you've had, even if you're not yet satisfied with the result.

HOW TO DOSE THE WATER PROPERLY

- Start by adding a drop of water to the middle of the paint in the pan. Personally, I use a pipette for speed and accuracy. Wait 1 minute for the pigments to reactivate.
- Wet the brush in the water pot, and give it a shake. All of the bristles should be thoroughly soaked. As you remove the brush from the water pot, give the bristles a wipe on the rim, to squeeze the excess water out.
- Dip the brush into the paint pan, and evenly coat the paint with the water on the brush. This will load the belly of the brush with pigments. You can now transfer this colour into your palette, or use it directly on the paper.

HOW TO PREPARE A DILUTE

- Once the pigments have been reactivated, soak the brush in water and use it to wash the water over the watercolour paint in the pan. Transfer the paint to one of the spaces you have made for your mixtures.
- The next step is to add water. The easiest and most accurate way, I find, is to use a pipette. A clean brush also does the trick.
- Dilute the pigments by making circles with the brush to even out the liquid. If you think your dilution is too light, add more pigments; if you think it is too concentrated, add more water.
- Now soak the brush in your mixture. With the belly loaded, wipe off the excess liquid on the edge of the palette or on a cloth. The colour is now ready to be applied to the paper.

There are three main watercolour techniques

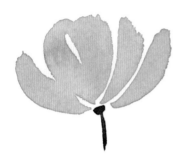

WET ON DRY

This involves applying wet watercolour paint to dry paper. This technique is used to create shapes with clean, controlled contours, or to add layers and details.

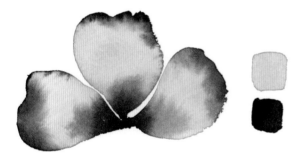

WET ON WET

This involves applying watercolour paint/pigments to an already wet surface. This technique is used to create fades or fusions.

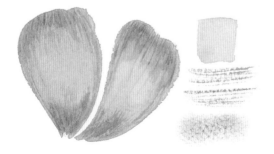

DRY ON DRY

This technique is not used as often as the previous two. A dry or slightly damp brush, soaked in pigments that have dried on the palette, for example, can be used to add a velvety hint of colour to a dry surface, or to add fine detail.

Different ways to hold your brush

Knowing what kind of lines or marks your brushes can produce is essential. All it takes is a few well-controlled brushstrokes. As you practise and start to get the hang of it, you'll gain in confidence and become more satisfied with the results. Here are some quick and easy exercises to help you master the three ways of holding a watercolour brush.

EXERCISE 1: HOLDING THE BRUSH UPRIGHT

1. Hold the brush upright and only apply the tip to the paper. Tilt the brush handle slightly to the right, and draw a thin line. Keep the pressure light and constant right to the end.

2. Repeat the same brushstroke as before, but apply more pressure; the belly of the brush should touch the paper this time. Keep the pressure constant throughout.

3. With your brush held upright, draw circles using only the tip of the brush.

*In the same way that you water
a plant and patiently watch it grow and flourish,
you can also enjoy watching your watercolour painting
come to life through the same acts of kindness.*

EXERCISE 2: THE BRUSH POINTING DOWNWARDS

1. Draw upward strokes with the tip of the brush.

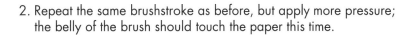

2. Repeat the same brushstroke as before, but apply more pressure; the belly of the brush should touch the paper this time.

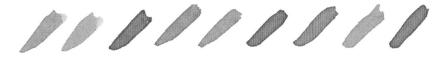

3. Combine movements 1. and 2. together = **tip-belly-tip.**

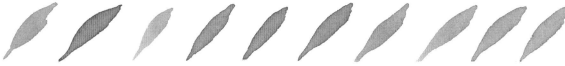

4. The **tip-belly-tip** movement, but curve the line slightly to the right.

5. The **tip-belly-tip** movement, curving to the right; the **tip-belly-tip** movement curving to the left.

6. These three brushstrokes, one after the other, give us a petal or a leaf. They form the foundation of numerous compositions, and come in all colours and sizes.

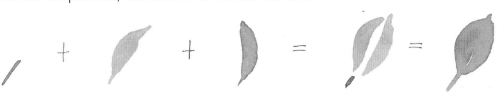

EXERCISE 3: THE BRUSH POINTING UPWARDS

1. Draw downward strokes with the tip of the brush.

2. Repeat the same brushstroke as before, but apply more pressure; the belly of the brush should touch the paper this time.

3. Combine movements 1. and 2. together = tip-belly-tip.

4. The tip-belly-tip movement, but curve the line slightly to the right.

5. The tip-belly-tip movement, curving to the right; the tip-belly-tip movement curving to the left.

6. The last three brushstrokes are done one after the other.

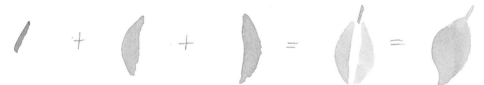

This tip-belly-tip movement can be lengthened for different effects; it can be used to produce long, tapering petals or lanceolate leaves, for example.

To get a more rounded shape, apply the tip, then the belly and then lift the brush off the paper.

NOW IT'S YOUR TURN!

Here's an exercise that will help you to brush up on the tip-belly-tip movement. Each sequence of gestures is represented by a specific colour. Pink, Payne's grey, ochre and green. Feel free to turn your piece of paper around so that the detail you are painting is in front of you.

Green: a downwards motion from the tip to the belly and back to the tip, curving to the left and right.

Pink: an upwards motion from the tip to the belly and back to the tip, curving to the left and right.

Payne's grey: using the tip of the straight brush.

Ochre: a long tip-belly-tip brushstroke in an upwards motion.

Gradients

To shade a colour, start by applying a circle of fairly concentrated paint. Then dip your brush in the pot of water and get rid of the excess liquid by wiping it on the rim. Paint another circle. Dip the brush again, wipe off the excess liquid, and paint a third circle. Do the same for the following ones.

Washes

A UNIFORM WASH

It's not easy to create a wash, but what's more, even if it's uniform without streaks or halos, there's still plenty to be frustrated about when you first try it out.

Don't get discouraged.

Use 100% cotton paper.
Start by preparing a dilute of the desired colour. Make a sufficient amount so that you don't have to stop to make more in the middle of your creation. To get a uniform wash, you need to paint quickly and all in one go.

Read and memorise the following movements to gain in confidence and speed.

A GRADIENT WASH

To create a gradient wash, the process is much the same as for a uniform wash, except that the colour will gradually lighten.

1. Generously load a large soft brush with the diluted colour of your choice. As before, start at the top left-hand corner and paint the top three lines.
2. When you reach the end of the line, rinse your brush thoroughly with water but do not wipe it on the rim of your water pot. Use this brush to dilute your already prepared colour, and stir it. Squeeze the water out of your brush by wiping it on the edge of your palette, and continue your wash over the drop that has formed on the paper. Continue your gradient by rinsing your brush regularly. The colour will progressively become lighter.

1. Generously load a large soft brush with the diluted colour of your choice. Start at the top left-hand corner and paint the entire top line horizontally, with the belly of the brush. Hold your brush flat so that more of the brush is in contact with the paper.
2. When you reach the end of the line, go down slightly, vertically. Paint the second line, this time from right to left, and collect the drop of wash that formed with the first brushstroke.
3. When you reach the end of the second line, go down slightly and do another horizontal line, left to right. Tilt your sheet of paper now and then. If necessary, refill your brush with the diluted colour and pick up where you left off. When you arrive at the bottom, absorb the last drop of wash with the tip of the wiped brush.

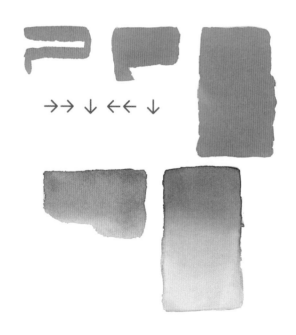

Textures

Here are some tips for creating textures.

1. Add fine salt to the wet surface and allow it to dry thoroughly.
2. Fine drops of hydroalcoholic disinfectant strongly repel pigments.
3. Clean drops of water on the drying surface.
4. White lines drawn in Neocolor wax crayon before paint is applied.
5. Scratches made with the metal part of a mechanical pencil on the wet surface.
6. The drying watercolour paint is scraped with the corner of a plastic card (old bank card).
7. Dots drawn in watercolour pencil on the still-wet surface.
8. When the watercolour paint is still drying, remove some of the colour with a clean, damp brush.
9. The fresh colour is absorbed by dapping it with a scrunched up tissue.
10. Spots of opaque white are added.

NOW IT'S YOUR TURN!

Try to copy the illustrations below, using the textures opposite.

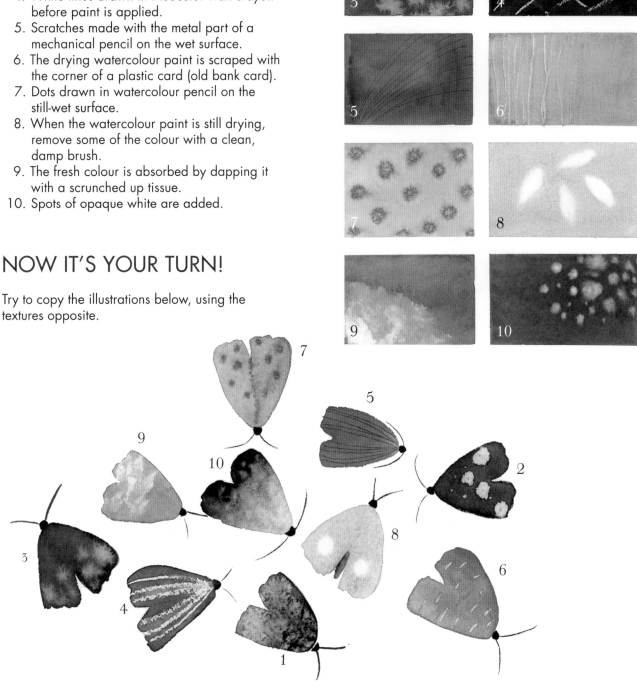

The preparatory sketch

It is sometimes helpful or reassuring to draw a few guidelines before you start painting. I use several methods:

- **A pencil sketch** that will be erased once the watercolour paint is completely dry. But sometimes you can still see the lines. If I think the line is too pronounced, I soften it before I start painting, using a simple eraser or, better still, a kneadable eraser. I tap it on small, precise areas and roll it on larger sketches.
- **A watercolour pencil** that blends with the water in the watercolour paint.
- **Friction markers** are great because the ink disappears completely with a quick blast of a hairdryer. I like to use a bright pink friction marker, particularly for outlining a precise, geometric shape that needs to be clearly visible, such as a rectangle or square, or for drawing a frame around a colour chart.

1

Correcting mistakes

You might find, on occasion, that your brush slips on the paper or that you have too much paint or water in the bristles and a drop falls in the wrong place. Here are some tips to correct any mistakes you make.

- **Rectify a demarcation line (1):** once the surface is dry, use a soft, damp brush to fade the line with circular movements.
- **Correct an overly pigmented surface (2):** sweep a wet brush over the area and dab it with a tissue to absorb the excess pigment, then blend the remaining colour with the brush and water.
- **Fade any veins that are too prominent (3):** go over them with the tip of a wet brush, then dab with a tissue.
- **Stains (4):** firstly, dab them with a tissue, then rub the marks with the end of a clean, damp magic sponge. Finally, dry the area with a tissue. You must wait until the paper is completely dry before painting over it.

2

3

4

Painting wildflowers
The anatomy of a flower and a leaf

Calyx = set of sepals
Corolla = all of the petals

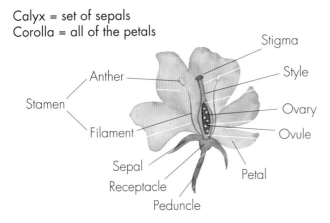

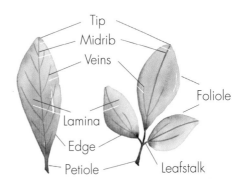

SIMPLE LEAVES

Simple leaves have a lamina that either has no slit, or has a minimal slit with divisions that do not reach the midrib:

- **Linear (1):** long, narrow and with parallel edges.
- **Lanceolated (2):** in the shape of a spearhead, the widest part is at the bottom, near the petiole.
- **Cordiform (3):** heart-shaped.

- **Oval** (or ovoid) **(4):** in the shape of an egg, the base is slightly wider than the top.
- **Serrated (5):** the edge of the lamina, which varies in size depending on the specific shape of each species, is saw-toothed.
- **Incised (6):** irregular cuts with deeper incisions than a simple jagged edge.

1

2

3

4

5

6

COMPOUND LEAVES

Compound leaves have a lamina that is completely divided right down to the midrib, giving the impression of several leaves united on a single petiole, but these are actually folioles.

- **Pinnate (1):** the folioles are arranged like the barbs of a bird's feather, symmetrically on each side of the spine (called the quill or calamus).
- **Trifoliate (2):** leaf composed of three folioles, which are all attached to the top of the petiole.

- **Palmate (3):** when there are more than three folioles attached to the top of the petiole, arranged in a fan, it is a palmate leaf.

1

2

3

How to simplify a flower

Working together, we're not going to create botanical illustrations that look exactly like the original plant. Rather, I'm going to show you how to paint flowers from looking at them, with particular focus on how to see them as simple shapes. I paint in a style you might call "**loose**", but I add a few specific details, a hint of botany, if you will. That's why I call it "**botani-loose**".

I suggest that when you paint a flower, you include its environment, the way it moves, its colours: a flower you can almost touch. Like a portrait painter looking closely at a face before creating a caricature of it. Features are exaggerated, angles are rounded, lines are simplified. Let's do the same...

OBSERVE AND SIMPLIFY

Illustration 1: the bush vetch
In this first example, the bush vetch (vicia sepium) of the fabaceae family.

Step 1: Observation
I start by taking a good look at the plant, either a freshly-picked flower, a photo from a recent walk or something I have found on the Internet. **What do its flowers look like, what colour are they, how many petals do they have, what shape are its leaves and how are they arranged on the stem?** I scribble a few sketches on a scrap piece of paper before switching to cotton paper.

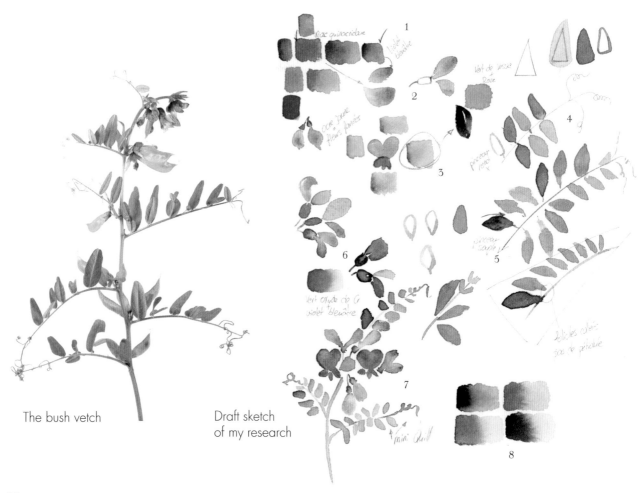

The bush vetch

Draft sketch
of my research

1. First, I look for the colours in my palette **that are closest to the colour of the flower.** For the bush vetch, quinacridone pink and a bluish purple will be perfect. No need to look any further.
2. A quick draft of the flower in profile: two teardrop-shaped brushstrokes.
3. Now, **I choose a shade for the leaves.** Again, from the pure colours in my palette.
 Sap green goes well with pink and violet, but I'd like it to be more of an olive green, to get a more complementary green in the colour wheel. I check my reference book with all the colours mixed together. I'll use a mixture of sap green + quinacridone pink.
4. I notice that they are compound leaves, one foliole in front of the other, in pairs. Those close to the stem are larger and decrease in size as they move away from it. Each foliole has a rather triangular or ovoid shape. Make a point of accentuating the tendrils!
5. I try out different brushstrokes, using a range of brushes, to find a simple way to recreate the shape of the leaves. From the inside out or the outside in, by pivoting my brush etc.
6. I've also noticed that the calyxes are rather dark, a sort of violet-green, rather than green.
7. Paint the details, the remaining leaves and the tendrils with the tip of the fine brush, using as little pressure as possible. Everything else can be painted with the medium round brush.
8. I check the palette I've chosen and whether the colours work well together.

Step 2: choices

Once these various observations have been made, it's time to decide which specific features should be included and which should not.

- Thin lines on the petals? **Without**

- Upper petals should be pink or purple? **Purple**

- Petals in a uniform colour or very gradated colour? **Uniform**

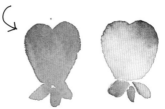

- Green or slate-coloured calyxes? **Slate**

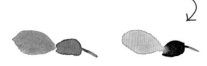

- Oval or ovoid folioles? **Ovoid**

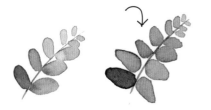

- With veins or without? **With**

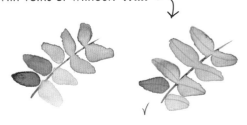

- But definitely include a lot of branching tendrils!

29

And here is the combination of all these choices for an initial attempt at the bush vetch.

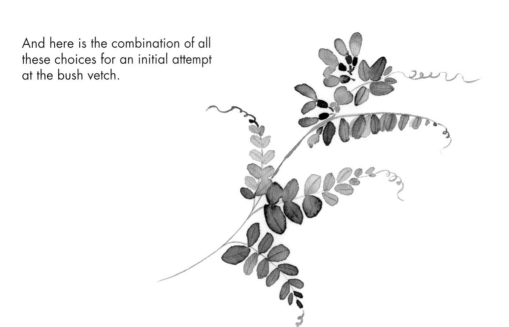

Illustration 2: the bladder campion

In this second example, the bladder campion (Silene vulgaris) of the Caryophyllaceae family.

Step 1: Observation

I start by taking a good look at the plant, either a freshly-picked flower, a photo from a recent walk or something I have found on the Internet. What do its flowers look like, what colour are they, how many petals do they have, what shape are its leaves and how are they arranged on the stem? I scribble a few sketches on a scrap piece of paper before switching to cotton paper.

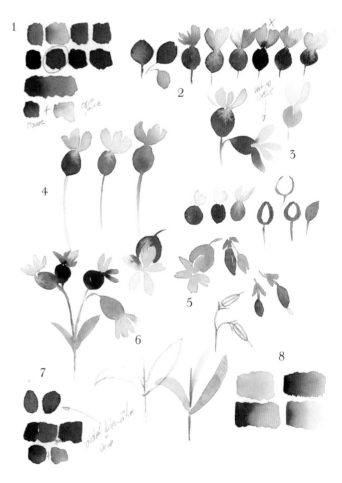

1. Again, I start by looking through my pure colours to find the ones that are closest to the colour of the calyx. For me, this is the most striking part of the plant, the bit I need to emphasise. The mixture of mauve and yellow ochre creates a beautifully muted purple hue; an intense but soft colour.
2. The difficult part is how to effectively illustrate the five white petals (see page 33). For this, I try out some light shades to give the effect of petals. First, Payne's grey, which is often used for white petals. I soon realise that Payne's grey is too close to my burgundy blend on the colour wheel (see page 12). I would prefer a more complementary colour, something from the other side of the disc. I want one of the greens with a yellow tinge, directly opposite. Sap green is a good choice.
3. How should I attack this plump, swollen shape? By drawing the outline and colouring it in?

Or with two nicely curved brushstrokes? I reckon the brushstrokes are the best option!
4. The stems now: I experiment with the sap green, then the purple mixture and finally the two blended colours. I like how that looks!
5. Maybe I'll add a few flowers seen from the front, and some buds too.
6. I choose another green for the leaves, to avoid monotony: chromium green oxide, which will match the greyish-green colour of the bladder campion's leaves. I love the way its leaves seem to wrap around the stem.
7. I think it would be more interesting to have another colour for some of the calyxes. A similar colour this time, the next one along on the colour wheel. I try out the bluish purple mixture with yellow ochre and I really like the result.
8. I check the palette I've chosen and whether the colours work well together.

Step 2: choices

Once all these various observations have been made, it's time to decide which specific features should be included and which should not. A few quick brushstrokes allow me to get an idea of what it will look like.

- Fine salt/ coarse salt / alcohol / scratches / handkerchief? **Fine salt**

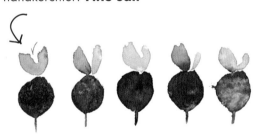

- Fine salt on its own or fine salt + scratching? **Fine salt + scratches**

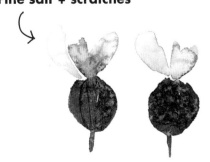

- For the buds, with or without? **With sepal**

- Stems with rigid or curved branches? **Somewhat rigid**

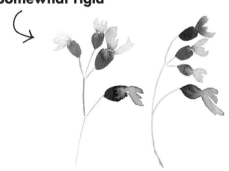

- Should the leaves be painted leaving some patches white? What about blurred edges? Should they be long and pointed or long and round? **Long**

- With veins or without? **Without**

- Stems painted in watercolours or drawn with a fineliner pen? **Watercolours**

- With stamens or without? **With**

And here is the combination of all these choices for an initial attempt at the bladder campion.

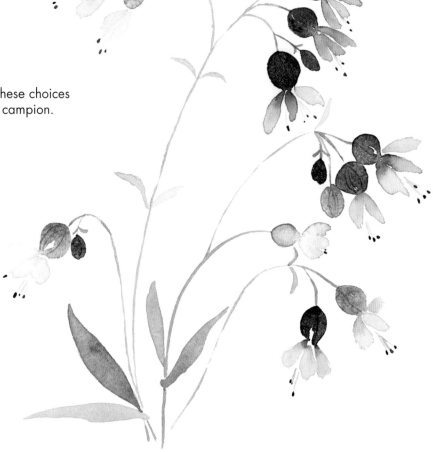

How to paint white flowers

White flowers can be a bit of a challenge to a novice watercolourist. White is a difficult colour to illustrate because, in watercolour paintings, it is by leaving the paper untouched that we suggest white. One solution is to apply colour around the flower so that it appears in the negative. Another solution would be to use opaque white (titanium oxide). However, this only works on coloured paper. Moreover, opaque white is not actually a watercolour but a gouache. This means that rather than looking at the actual colour of the flower, you should look at **the colour you perceive it to be.**

The dark, highly pigmented colours in my palette, pure or mixed, are practical shortcuts for obtaining very nice blacks, with a value close to 1 (see page 16). These colours are the magic ingredients that create the illusion of white petals. How is that possible, you ask? Well, because when they are very diluted, they produce magnificent, warm, natural greys.

The all-category champion is **Payne's grey:**

And runner up is **Vandyck brown:**

But some mixtures are even more interesting:

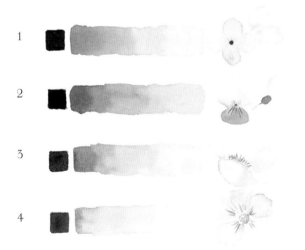

1. Payne's grey + Vandyck brown
2. Payne's grey + light azo yellow
3. Payne's grey + twilight yellow
4. Payne's grey + ochre yellow

5. Vandyck brown
 + quinacridone pink
6. Vandyck brown
 + chromium green oxide

7. Vandyck brown
 + indanthrone blue

Creating an inspiring herbarium

A natural herbarium

In order to have wildflower specimens to paint all year round, I advise you to be like a botanist and make your own herbarium.

There are various ways you can dry garden flowers and wild plants. First of all, it's best to pick the plants in dry weather, so as to have as little moisture as possible.

AIR

The first method I use is to just leave them to dry out naturally. I hang the flowers or small bouquet upside down on a rope stretched between two walls, in a dry place with plenty of air flowing through. Then I hang them up with string, making sure to keep enough space between the different plants, to prevent mould from developing. This method has the advantage of maintaining the plant's volume. For St. John's wort, field scabious, sage, etc., cut the flowers at the beginning of the flowering period. Remove the leaves and make bouquets of 5-8 flowers. Tie them together with hemp twine, but not too tightly. Forget about them for a couple of weeks to a month.

PRESS DRYING

The first virtue of a wooden press is how easy it is to use. It has two wooden panels between which you can slide cardboard and sheets of paper, and a screw system in each corner creates a vise. Here's how to proceed:

1. The wooden base of the press.
2. Thick cardboard.
3. A sheet of paper.
4. Place some flowers on it.
5. Another sheet of paper.
6. Another layer of flowers.
7. Thick cardboard.

Once you have laid out all the flowers you want to dry, close the press and tighten the screws. Leave it like this for one month. Once the plants have dried, here are two ways to preserve them: stick them to a thick sheet of paper using small strips of self-adhesive tape (like a herbarium), or do as I do and slip them into transparent plastic bags. Arranged in a document holder, this storage system not only protects the dried wildflowers, but also makes them easy to admire. Perfect for sparking inspiration in winter, or for recalling the shape of leaf X or flower Y at a moment's notice.

A painted herbarium

Here you'll find wild plants with simple lines:
just perfect for filling in any gaps or embellishing
your bouquets, wreaths and so on.

Dip into these samples as often as you like!

Lady's
bedstraw

Lucerne

Old man's beard

Corncockle

Redshank

Sweet woodruff

Meadow
sage

Spiked
rampion

Great
burnet

Spiny sowthistle

Field
bindweed

Quaking-grass

Reedgrass

Great
wood-rush

Meadow-grass

How to organise your creative workspace

I don't have a separate room that's just for watercolour painting, but I've set up a creative area in the corner of my main room. My workspace is facing a large window, so it's perfect for light and inspiration. It's important that I have a space that allows me to spread my equipment out and leave it that way, without having to put everything away when I stop painting. It doesn't have to be all that large, but it does have to be nice and quiet and, above all, it has to be somewhere that keeps me feeling motivated.

Here's how I arrange my equipment so that I'm comfortable when I paint. Of course, this arrangement should be reversed for a left-handed person.

You should have all your equipment close to hand, but only what you need. The aim is to have enough room to be able to turn your sheet of paper around without knocking anything over. So remove anything you don't need.

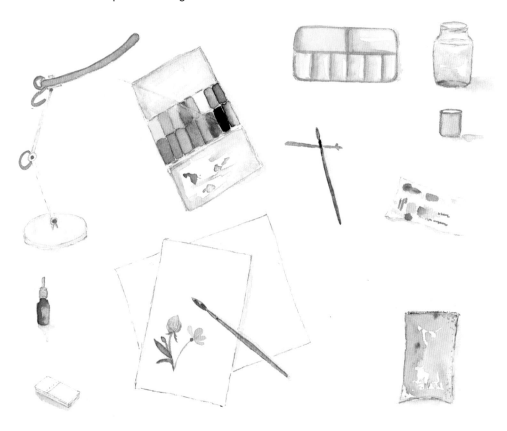

On my left: a lamp, to light my paper from the other side (because I'm right-handed) so as to avoid casting shadows with my hand; the glass jar with pipette to reactivate the watercolour pigments; tissues.

In front of me: my ceramic palette where I prepare my mixtures, my brush rest with a brush lying on it, and my box of watercolour paints. I put the colours close

together so that there is a short distance between the pans and the paper, to avoid dripping.

On my right: tissues, pieces of paper for trying out colours, and two jars of water. A large one for rinsing brushes and a smaller one that always has clean water in it.

20 flowers to paint

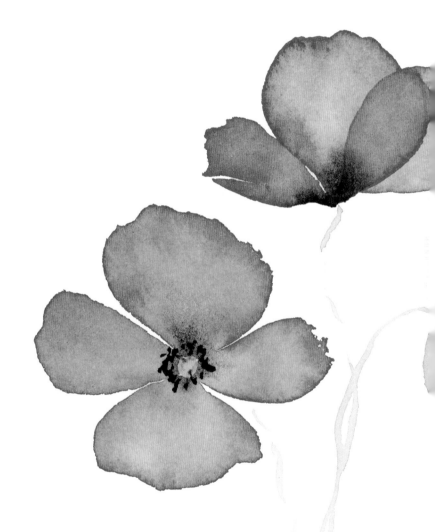

Pink

38 *Rosehip*
42 *Fireweed*
46 *Sainfoin*
50 *Red Clover*

Red

54 *Red Campion*
58 *Poppies*
62 *Snake's Head Fritillary*

Violet

66 *Common Comfrey*
70 *Common Mallow*
74 *Field Scabious*

Blue

78 *Harebell*
82 *Woodland Geranium*

Yellow

86 *Water Avens*
90 *St. John's Wort*
94 *Dandelion*
98 *Buttercups*

White and other colours

102 *Chamomile*
106 *Ribwort Plantain*
110 *Meadowsweet*
114 *Black Elderberry*

Rosehip

EQUIPMENT

- 1 fine brush
- 2 medium round brushes
- Pencil
- Eraser

COLOUR PALETTE

Rosehip:
Quinacridone
pink
+ yellow ochre
+ opaque white

Yellow ochre

Rust:
dark azo yellow
+ Vandyck
brown

Chrome:
light azo yellow
+ Payne's grey

Azo yellow light

How to recognise it

By its flowers: 5 pale pink petals, ephemeral flowers (May to July) supported by thorny stems, which are initially erect and later start to droop.
By its leaves: toothed, oval leaves composed of 5 folioles.

By its fruit: red-orange, edible. The rosehip ripens between September and October.
Its height: 1 - 5 metres.
Its habitat: hedges, edge of woodlands, wastelands, scrub.
Altitude: 200 - 1,600 metres.

HOW TO PAINT IT

1

3

4

1. Rosehip petals are regular in shape. In order to position its five petals more easily, use a pencil to draw a circle and five equally distributed branches that will serve as a guide.
2. Using the medium round brush and the rosehip pink mix (the opaque white adds a velvety, powdery quality) paint generously-sized petals. With the brush positioned downwards, first place the tip just above the central circle.

Work your way upwards, bringing the belly of the brush up to the circle, and then lift it off again.
3. The edges of the rosehip petals undulate gracefully. So you're going to continue with a wavy line.
4. Repeat the same brushstroke as in step 2, starting from the central circle and working your way towards the wavy edge. This will form the outline of the first petal.

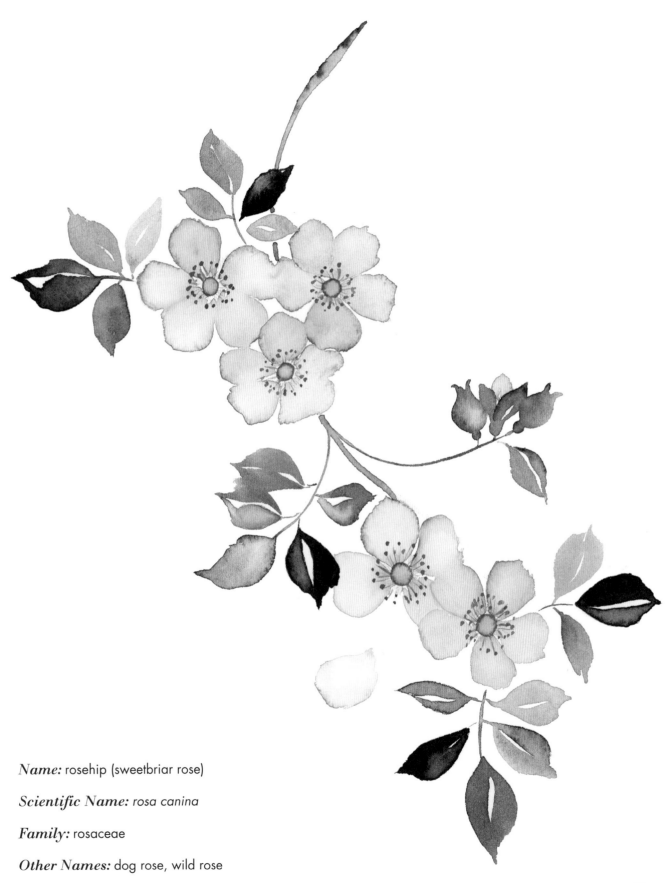

Name: rosehip (sweetbriar rose)

Scientific Name: rosa canina

Family: rosaceae

Other Names: dog rose, wild rose

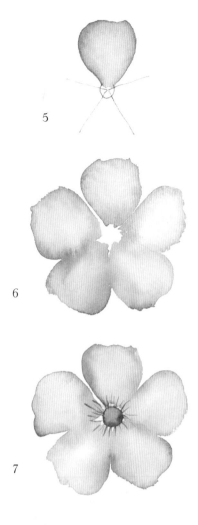

5. The petals of this wild rose are usually more pigmented at the edges. To reproduce this effect as simply as possible, load the second round brush with clean water. Rub the brush in a back-and-forth motion and left to right, to soften the colour you have already applied, creating a nice blurry finish.

6. Now paint the other petals in the same way. Take care to add a hint of **yellow ochre** to the root of each petal while the surface is still damp. If the petals are already too dry, you can wet them slightly with clean water.

7. For the middle and the stamens, a fine brush will be more suitable.
 The rust-coloured mix perfectly complements the soft pink of the petals. Draw the edge of the circle with the tip of your brush and add very diluted paint to the centre. Barely touch down with the brush, and use a sweeping motion to create the finest lines possible.

8. To represent the anthers, paint tiny circles with the highly concentrated **Rust** colour. Be careful not to make them too regularly spaced.

9. Once dry, add short bursts of the **light azo yellow** to brighten up the centre of your flowers.

HOW TO PAINT ITS LEAVES

The leaves are composed of five jagged folioles that are bluey green in colour. To give the illusion of slightly jagged edges, you don't want to paint the leaves with perfectly smooth contours, as in the example below. Good Lord, no!

No smooth outlines like those shown here!

1. Load the round brush with the chrome mixture and point it downwards as you start by painting the left half of the leaf. Use the tip of the brush, then squash the belly as you drag the bristles in an upwards motion. Apply less pressure to the brush as you paint in a wavy motion, before removing the brush entirely.

2. Do the same for the right half of the leaf. The leaves will look beautifully natural. Let the paint dry before you move on to the final details.

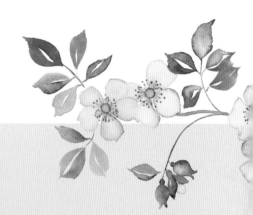

WHY YOU SHOULD LOVE THIS PLANT

This wild rose is the champion of all plants containing **vitamin C.** It exceeds kiwis, lemons and other citrus fruits. Rosehips are harvested after the first frosts in autumn, as the fruit softens and becomes sweeter and fuller. This season is a real treat for fans of delicious homemade rosehip jam.

However, real fruits are the hairy, prickly achenes contained in the fleshy red husk. Resembling seeds, these mini-fruits are surrounded by characteristic prickly hairs, hence their nickname "butt scratchers" or "graippe-tiu", as we say where I come from. Its other name, "dog rose", comes from the fact that the plant's root was once thought to cure rabid dog bites.

It should be noted that the beach rose (Rosa rugosa) produces larger fruits that are used in the same way as rosehip (jam, syrup, confit, herbal tea, etc.). This Asian rosehip is often planted in Western gardens for ornamental purposes.

Rosehip Jam

1 kg of frozen rosehip
1 litre of apple juice
750 grams of sugar
4 soup spoons of lemon juice

Preparation

1. Remove the stems and the peduncles from the rose hips.
2. Put the fruit in a large container. Pour the apple juice over the top and leave to soak for around 3 days, covered, in the fridge.
3. Bring the rosehips and marinating liquid to the boil in a large saucepan.
4. Lower the heat and let it simmer for approx. 1 hour, with the lid on. When the fruit is soft, drain the liquid off.
5. A portion at a time, pour the fruit into a blender and then pass it through a sieve, using the same saucepan.
6. Stir in the sugar and the lemon juice as you bring the mixture back to the boil. Cook for around 20 minutes at a rolling boil. Keep stirring!
7. Test to see if it has cooked for long enough (see cooking test, below).
8. Pour the boiling jam into clean, scalded jars (all the way up to the brim) and seal immediately. Turn the jars over, standing them on the lid for a moment.

Cooking test: spoon some of the boiling jam onto a plate and leave to cool. If it sets and forms a thin skin, the consistency is good. If not, boil the jam a little longer and repeat the test.

Tip: if the rosehips are still hard because they were picked before the first frosts, simply freeze them for 2 to 3 days.

Storage: approx. 12 months, in a cool place away from direct sunlight. Once opened, keep the jar in the refrigerator and consume the jam within a few days.

Fireweed

EQUIPMENT

- Fine brush
- Medium round brush
- Large flexible brush
- White watercolour pencil
- Pigma Micron fineliner 01 cold grey

COLOUR PALETTE

Oak:
chromium green oxide
+ quinacridone pink

Perylene red deep

Opaque white

Quinacridone pink

Payne's grey

How to recognise it

Its flowers: 4 dark pink petals, arranged in long clusters on a straight, reddish stem.
Its leaves: numerous narrow, lanceolate leaves that are often wavy along the edges.

Its size: 50 - 150 cm.
Its habitat: embankments, scree, mountainous woodlands, clearings.
In bloom: June to August.
Altitude: 200 - 2,500 metres.

HOW TO PAINT IT

As you paint this beautiful wildflower in watercolours, the key phrase will be: move away, move away to lighten the load! Move the petals away from each other to expose the heart. Move the flowers far enough apart but keep them gathered around a central axis. Move the leaves away so that they barely brush against the stem.

1

2

1. Paint 4 petals in quinacridone pink. The brushstroke to create these well-rounded petals is very specific.
With your medium round brush in an upwards position, apply the entire belly of your brush to the page. While maintaining the pressure, bring your stroke downwards and then raise the brush off the page in a sudden movement.
2. Do the same for the right side of the petal. The petal will then be generous at the top

3

4

and tapered towards the centre of the flower.
3. Do the same for the other petals, varying pigment concentrations if possible. Feel free to turn your piece of paper around so that the petal you are painting is in front of you. You will be able to move more freely. Use very diluted paint to create a light, delicate quality to a few of the petals.
4. Paint the 4 fine sepals, in red, between each petal. Use the fine brush for precision.

Name: fireweed

Scientific Name: chamaenerion angustifolium

Family: onagraceae

Other Names: great willowherb, rosebay
willowherb, bombweed, Saint Anthony's laurel

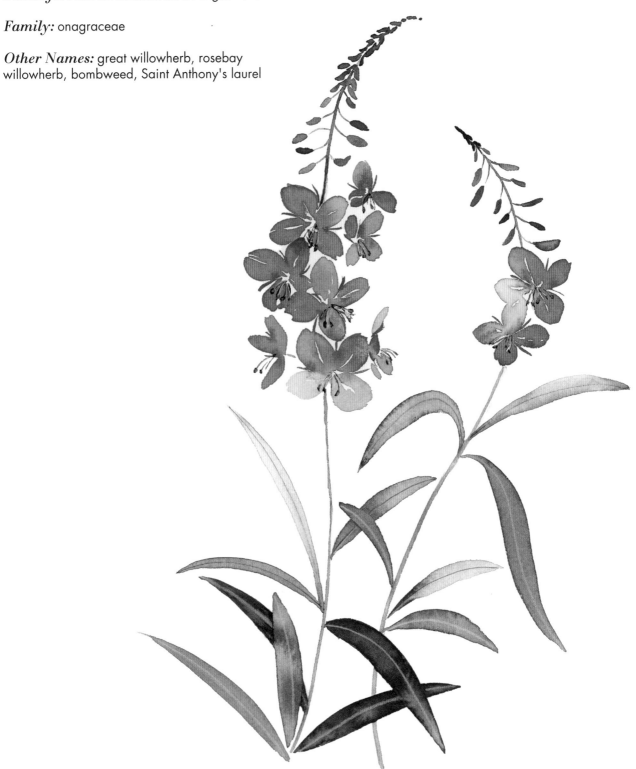

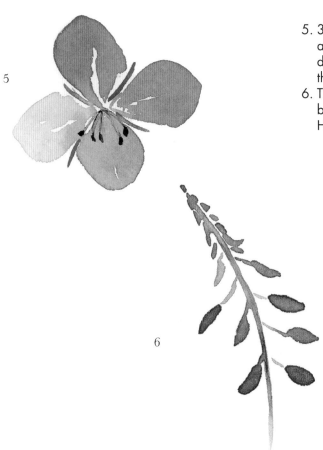

5

6

5. 3-4 stamens in highly concentrated Payne's grey add the finishing touch to your flowers. Once dry, I like to add a line of opaque white to give the powdery effect of pollen-filled stamens.
6. The buds are small and green at the top, becoming larger and pinker as they descend. Here too, the fine brush will be more suitable.

HOW TO PAINT ITS LEAVES

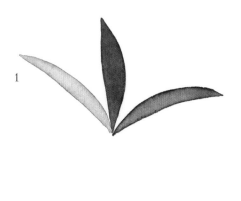

1

2

1. Prepare a sufficient amount of the oak mixture, which you can use on all of the foliage. Load the large, soft brush with this deep green and, in a single stroke, form a leaf. With the brush in a downwards position, gently place the tip onto the page and then, in a long upwards motion, apply a little more pressure to the belly of the brush. If necessary, reshape the parts of the contour that you don't like as much. However, keep the leaves narrow and elongated.
2. On highly pigmented leaves, use a white pencil crayon to draw the prominent midrib and a grey fineliner pen for lighter areas.

The will to succeed in watercolour painting is a driving force, but even more important is being able to really enjoy the process, whatever the result!!

WHY YOU SHOULD
LOVE THIS PLANT

The fireweed has a flair for showmanship. Oh yes indeed, and it is above all its flowers, like long dark pink arrows rushing towards the sky, that catch the eye. As fireweed grows in colonies, the slightest breeze seems to makes them perform in a skilfully choreographed ballet. This widespread perennial is so vibrant and graceful with its long, undulating stems.

The fireweed is a pioneer. It has the unique ability to replenish soils depleted of organic matter, for example after a forest fire. But as soon as humus accumulates in the soil and other plants start to reappear on the burnt areas, the fireweed relinquishes its hold. It is pointless to look for it in a dark forest, **fireweed loves the sun and flourishes in open terrain.**

Fireweed can also be consumed as a drink. Have you ever heard of Ivan Tea (or Ivan Chai)? It is a traditional Russian herbal drink, obtained by brewing fermented fireweed leaves. Ivan tea did not come about because of the plant's exceptional properties, but rather because of its similarity to Chinese black tea. Around 1850, a diplomat on a trip to China with Catherine II of Russia is said to have discovered tea-making there. At the time, this raw material imported from China obviously cost a fortune. The Russian dignitary was eager to memorise and document the procedure. Back in St. Petersburg, he experimented with the technique on a variety of local plants, achieving impressive results with fireweed leaves. He quickly set about the manufacture of this substitute "tea". This highly profitable industry then spread to all regions of the country where the plant grew. The 1917 revolution brought a gradual end to the marketing of this tea.

Today, the production of fermented fireweed has picked up again thanks to the growing demand for natural and healthy products. These days, it is widely recognised for its many nutritional and medicinal virtues.

Fireweed is a vegetable. Its young leaves provide an excellent wild vegetable. Sautéed in a frying pan or wok, like one might with Asian vegetables, its leaves are a delicious treat. Or, when cooked for longer, its thickening properties can be used to bind vegetable stews or soups.

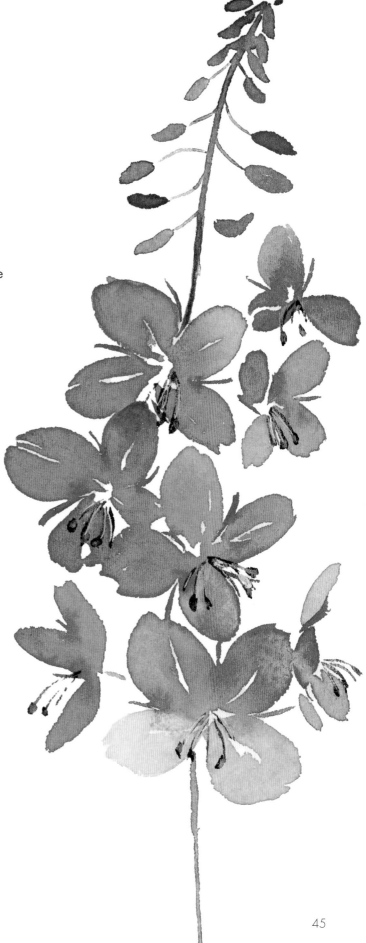

Sainfoin

EQUIPMENT

- Fine brush
- Medium round brush
- Pencil
- Eraser

COLOUR PALETTE

Fuchsia:
quinacridone pink
+ cobalt blue

Cankerwort green:
sap green
+ bluish purple

How to recognise it

Its flowers: clusters of pink flowers with fine purple veins.
Its leaves: furry, 13 to 25 folioles.
Its size: 30 - 70 cm.
Its habitat: limestone terrain, dry grasslands, roadsides, embankments.
In bloom: May to August.
Altitude: 200 - 1,500 metres.

HOW TO PAINT IT

1. Start by observing the outline of the Sainfoin plant. The clusters form a triangle shape. Use a pencil to faintly sketch out the circumference and stem.

2. For the leaves, a simple pencil line will allow you to paint all the foliage with confidence. The foliole at the end will help you too.

3. Before you start painting the flowers, prepare two different blends of the fuchsia mixture. The first tending towards pink and the second towards purple. These two blends will allow you to have fun varying the different parts of the flowers.
 Use the fuchsia-pink mixture and your medium round brush to paint the left-hand side of the flowers.

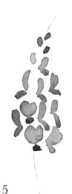

4. Then paint the right-hand side, to form a kind of heart shape. Now load your fine brush with fuchsia-violet. Quickly paint a small triangle underneath, allowing the two shades to mix together.

5. Continue to paint your cluster of small flowers, the middle ones seen from the front and the ones on the sides in profile.

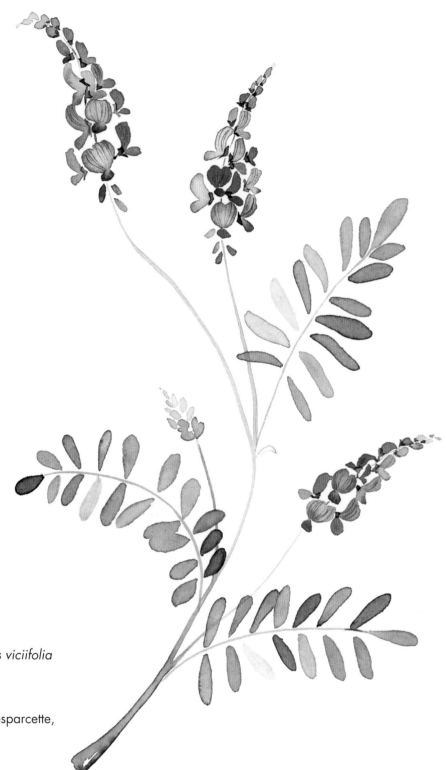

Name: sainfoin

Scientific Name: onobrychis viciifolia

Famille: fabaceae

Other Names: vetch-leaved esparcette, esparcet, holy clover

HOW TO PAINT ITS LEAVES

Now for the foliage: I have to confess my love for its beautifully oval and perfectly symmetrical leaves that are arranged in pairs.

1

1. Take the cankerwort green mixture you have prepared, dilute it and use the tip of your medium-sized brush to draw the outline of the first foliole. To make them appear to be more lightweight, paint each foliole a small distance away from the central line.
2. Do the same way for the other folioles, alternating different concentrations of the cankerwort green mixture.

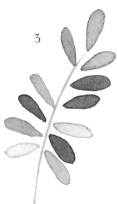

3

3. Using the tip of the brush, draw a green line to represent the petiole. Before moving on to the next part, make sure your watercolour painting is completely dry.

2

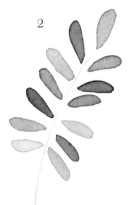

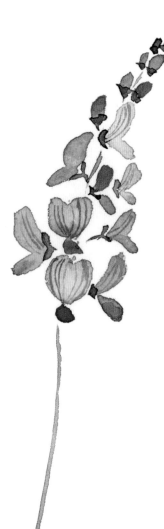

Using a fine brush on the smaller details will add a delicate touch to your watercolour in the blink of an eye!

- Draw fine veins with the fuchsia-violet concentrate mixture. You'll get a finer result if you use a slightly damp brush.
- Add the calyxes and stems.

Take things one step at a time, don't get discouraged. You've managed to create a beautiful and graceful wildflower.

WHY YOU SHOULD
LOVE THIS PLANT

In French, it is known as the *esparcette*... such a pretty word! It almost sounds like an adorably outdated first name. Much sweeter to the ear than its English name: sainfoin!

As well as being a beautiful wildflower, the sainfoin is a highly sought-after forage plant with many interesting properties. Its cultivation was widespread before the introduction of lucerne. Chemical dewormers for livestock are becoming increasingly ineffective; thanks to its tannins, sainfoin is proving to be a good **natural solution for parasite control.** One of the world's leading research institutes for organic farming has been studying it for years. A handful of farmers have embarked on cultivating it.

What an idyllic sight it must be to behold an entire field of sainfoin! This plant is so graceful, with its long, tufted pink stems waving in the slightest breeze. I have to admit that I was thrilled by the idea of studying sainfoin for this watercolour painting; as early as May, I was already watching out for the first leaves to appear. As the weeks passed, I made the most of every walk, every car ride, tirelessly scanning the roadsides... but there was nothing! Yet, in my childhood memories, there were always plenty of them. And in recent years too, right? But in those very same places, it had disappeared. I finally found a few scattered clumps later in the season, but it has to be said that the beautiful sainfoin is no longer as abundant as it once was.

Red Clover

EQUIPMENT

- Fine brush
- Medium round brush
- Pencil
- Eraser
- Pigma Micron fineliner 01 cold grey

COLOUR PALETTE

Magenta: quinacridone pink + bluish purple

Soft green: chromium green oxide + azomethine green yellow

How to recognise it

Its flowers: ball-shaped inflorescence composed of numerous tiny pinky-red flowers.
Its leaves: composed of 3 oval folioles decorated with a light patch.

Its size: 15 - 50 cm.
Its habitat: meadows, roadsides, open woodland.
In bloom: May to October.
Altitude: 300 - 2,400 metres.

HOW TO PAINT IT

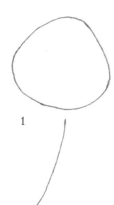

1

2

1. As observed in the description, the flowers are grouped together to form a ball. Do a pencil sketch of this shape as a guide.
2. Prepare a highly diluted magenta mixture. Using the round brush, paint delicate lines all the way around, pressing your brush lightly against the paper. For more realism, vary the direction of the brushstrokes a little.

3

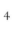

4

3. Also complete the inside of the inflorescence, and leave it to dry.
4. Now use a more pigmented colour and create volume by superimposing the first brushstrokes. Then prepare the Magenta mixture, but this time make it more concentrated.
Using the fine brush, go over each line again, but not so much that the lines underneath disappear completely.

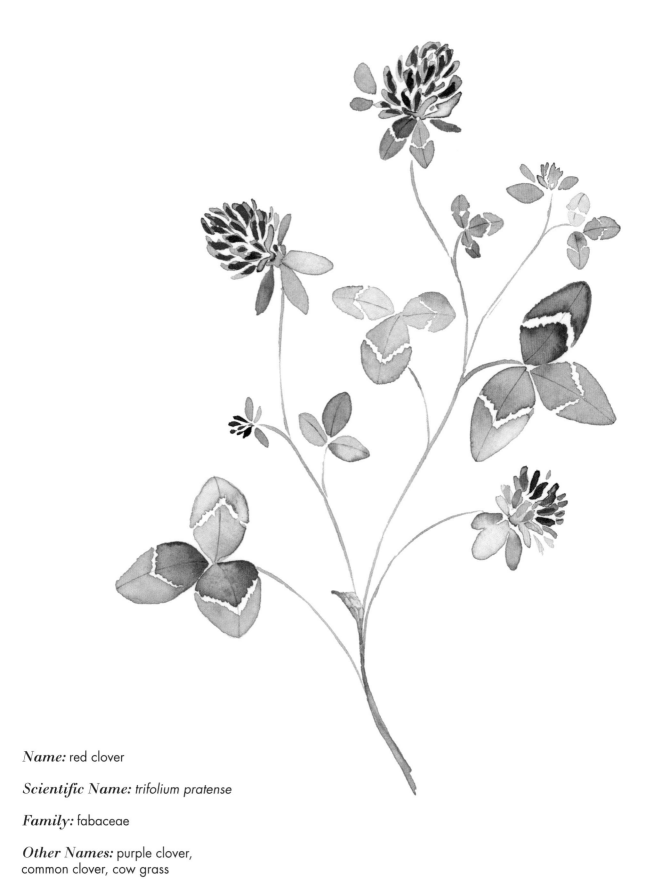

Name: red clover

Scientific Name: trifolium pratense

Family: fabaceae

Other Names: purple clover,
common clover, cow grass

HOW TO PAINT ITS LEAVES

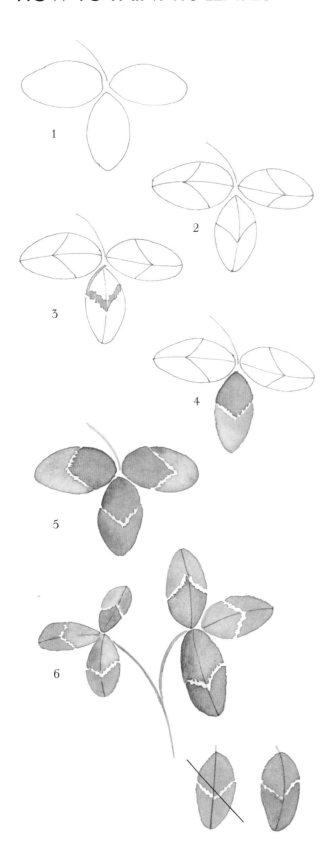

The clover is identified by the shape of its leaves: 3 folioles with light patches.

1. Pencil sketch three oval shapes to mark out your leaves.
2. Draw the midrib and a "v" shape. The light patch is usually in the middle of the clover leaf.
3. Paint the leaves with the soft green mixture. Simply use the tip of the round brush to draw the outline, then do straight brushstrokes close together, using the "v" shape as a guide. Colour in the upper part of the leaf, above the "v" shape.
4. Continue by painting the lower section in the same way, making sure to leave a white space in the shape of a "v".
5. Paint the other two leaves in the same way. Once dry, you can remove the pencil strokes with an eraser.
6. In my opinion, adding a fine line in felt-tip pen is a nice way to finish off these clover leaves.

For a very natural look, remember to use a curved line rather than a rigid, straight one (see example opposite).

WHY YOU SHOULD LOVE THIS PLANT

We all know the red clover or his brother the white clover because of the quest for the four-leaf lucky charm! But there is so much more to this plant than that.

There are no less than a hundred species of clover in Europe. The most common being the red and white varieties. First and foremost, it is a common forage crop that grows almost everywhere, both on the plains and in the mountains. It is an excellent quality forage because **it is very rich in protein.**

Its thick vertical root makes red clover particularly hardy. This means it can grow back several times after being mown, allowing three to four harvests a year. It is also a popular **green fertiliser** that is used to enrich the soil with nitrogen.

In the evening or early in the morning when the clover is in full bloom, it's amazing to spot a hare in the middle of its meal. It is not uncommon to come across this mammal, which is fond of munching on flower buds.

And to understand why it is so keen on them, all you have to do is pick an inflorescence, gently pluck a small tube-shaped flower and suck on the sweet nectar that is found at its base. A real meadow delicacy, well... that's if a bumblebee hasn't got there first! The glands containing nectar are hidden deep inside the flower. Pollination can only be carried out by long-tongued insects such as butterflies and bumblebees. The bees' proboscis is too short, **so the clover is not melliferous.**

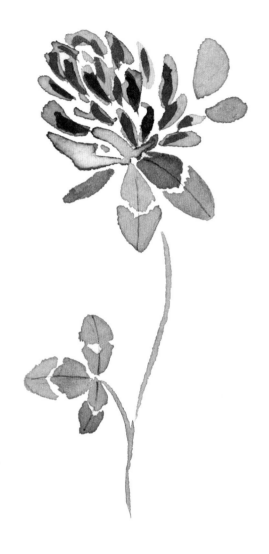

Delicately removed from the ball inflorescence, the small pink flowers will wake up a fruit salad or slice of buttered toast.

Despite its seemingly insignificant appearance, this flower is absolutely fascinating when viewed through a magnifying glass. Here we discover details such as five petals that resemble tiny butterflies resting on faint lines.

The leaf itself has often been used as a **decorative motif.** Gothic art (12th-15th centuries) saw the **symbol of the Trinity** in its 3-part leaves.

Its recognisable shape became a particularly popular decorative motif in cathedral sculptures and the margins of scriptures. The clover leaf is also commonly found on the coat of arms of the most prominent noble families.

As a reference to land workers, the clover became one of the four emblematic symbols of card games in the 15th century (known as the suit of "clubs" in English).

Well done!
You gave it a go...
You created something...
Never lose your enthusiasm!

Red Campion

EQUIPMENT

- Medium round brush

COLOUR PALETTE

 Quinacridone pink

 Cankerwort green: sap green + bluish purple

 Burgundy: perylene red deep + Payne's grey

How to recognise it

Its flowers: grouped together, each having 5 petals that are an intense reddish-pink and divided in two, with a deep burgundy calyx. They are only open during the day.
Its leaves: long, oval and pointed, furry and often curved.
Its size: 30 - 80 cm.
Its habitat: wetlands, meadows, roadsides, forest edges.
In bloom: April to September.
Altitude: 300 - 2,000 metres.

HOW TO PAINT IT

1 and 2

For this watercolour painting, you will only need one brush!

1. Start by preparing the cankerwort green mixture, which will be useful for painting the stems and the leaves. To add contrast and depth to your composition, paint long grasses in the background. Take some of the green mixture you have made and dilute it until it is very pale.
2. Using this green mixture, start to paint long grasses, first applying the tip of the brush, then applying light but even pressure. To make natural-looking grass, make a few random brushstrokes in different directions.
Don't worry if your features look too light, they will become more prominent as they dry. Allow this first coat to dry before continuing.

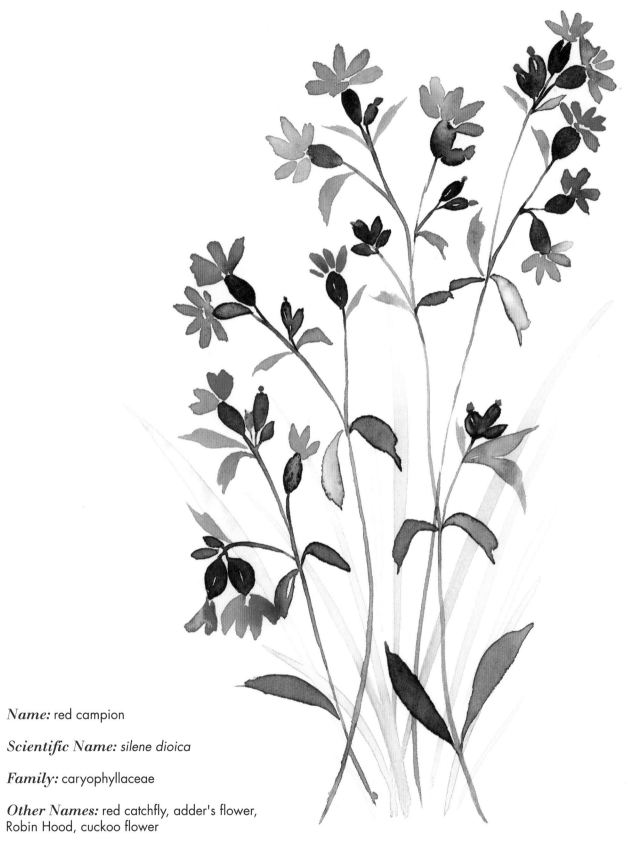

Name: red campion

Scientific Name: *silene dioica*

Family: caryophyllaceae

Other Names: red catchfly, adder's flower,
Robin Hood, cuckoo flower

3. Now prepare a concentrated burgundy blend. It will be your best tool for creating calyxes and buds. Start with a few calyxes in the middle of your leaf. To shape the left side of the calyx, use the tip of the brush, then gently squeeze the belly before working your way up, and finally removing the brush at the end. Repeat the same technique alongside the first brushstroke, to obtain the right side of the calyx. Paint a multitude of these, randomly, without thinking too much.

4. Quinacridone pink paint will create luminous petals. Using the tip of the brush, paint over the still damp burgundy calyx, then squeeze the belly of the brush before quickly removing it. Think of it as though you are using your round brush like a stamp. Vary pigment concentrations to create some light petals and more pigmented ones. Paint all your calyxes except the smallest ones, which will be the buds (see point 6).

5. While the burgundy mixture for the calyxes is still wet, take the opportunity to draw the stem with the cankerwort mixture. For ease and accuracy, turn your page or pad around. Start with the main stem, painting from the centre of the calyx and brushing outwards to the edge of the leaf. The burgundy colour will merge with your green. With your paper still turned around, connect the other elements to the main stem. Leave your watercolour painting to dry before adding the leaves. That way, you will be able to paint the final details without fear of smudging it with your hand.

6. Now have fun adding the beautifully drooping leaves, still using that same tip-belly-stroke-tip technique. A tiny drop of pink at the top of the buds will complete your composition.

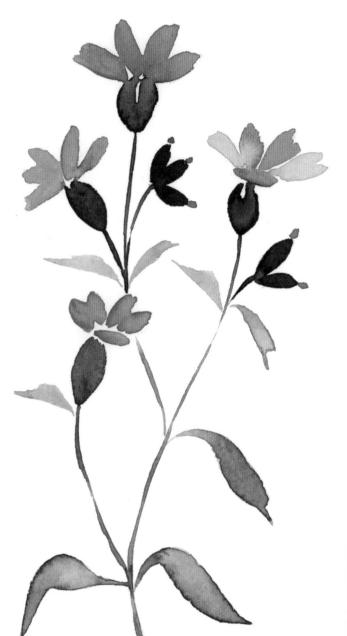

WHY YOU SHOULD LOVE THIS PLANT

It looks a bit like a carnation, right? Yes, and this is normal because the red campion and the carnation are from the same family (the Caryophyllaceae).

Easy to spot, the red campion illuminates a rural bouquet and can be gathered from embankments alongside country trails. So, why not make it an ornamental plant for your garden or balcony? Hidden away in capsules, its black seeds are easy to harvest at the end of the season. There are two ways to cultivate red campion. Either sow the seeds directly in the ground as early as September and wait until the cold season is over, or wait until the following spring, and then plant the harvested seeds in a pot. Once the plant starts to germinate, it requires no further maintenance. Even when they start to fade, its clusters of pink-red flowers are always radiant and decorative. It's always a pleasure to watch bumblebees and butterflies feast on their nectar.

The red campion's sturdy root contains saponins (detergent substances that, when mixed with water, produce foam when stirred). In the past, it was used to make laundry detergent and soap. Another lesser-known fact is that the red campion's male and female flowers grow on different plants.

Gourmet tip
The red campion's young leaf rosettes (before the flowers grow, otherwise they become more bitter) taste like peas. They go well with grilled potatoes. Sauté 1 onion in butter, add 3 finely cut raw potatoes, and sear for 5 min. Add the chopped red campion shoots, season with salt and cook for 15 minutes with a lid on. Turn them over and cook for a further 15 minutes, keeping the lid on. It's ready!

Well done, you've successfully germinated red campions! Listen to the bees buzzing and the birds singing.

Poppies

EQUIPMENT

- Fine brush
- Large flexible brush
- Pencil
- Eraser

COLOUR PALETTE

Poppy red:
perylene red deep
+ dark azo yellow

Opaque white

Soft green:
chromium
green oxide
+ azomethine
green yellow

Payne's grey

How to recognise it

Its flowers: 4 crimson red corrugated petals, often with a black spot at the base. The fruit is a green, oval capsule containing tiny seeds that will be scattered by the wind.
Its leaves: serrated, jagged and hairy.

Its size: 30 - 70 cm.
Its habitat: fields, rubble, roadsides.
In bloom: May to September.
Altitude: 200 - 1,800 metres.
Warning: the plant contains a slightly toxic sap.

HOW TO PAINT IT

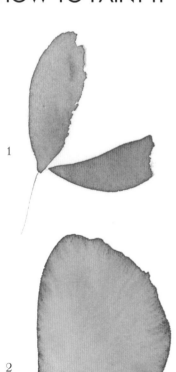

1

2

1. First, use your hands to visualise the shape of the poppy. It always has 4 petals with wavy edges that form a sort of cup. Let's start by painting the flower in profile. Once you've lightly marked out the top of the stem in pencil, prepare your diluted poppy colour mix. Load your large, soft brush with this mixture, then form the first petal (the one underneath) by applying the tip of the brush and then squeezing the belly in an upwards movement. It is easier to paint the left edge first in a large soft brushstroke, and then the right edge, so you don't smudge the wet watercolour paint with your hand (or vice versa if you are left-handed).

2. Using the tip of your brush, draw a wavy line around the top edge of the petal to give that crinkled effect. Colour in the entire petal straight away. Using another brush loaded only with clean water, add a little drop of water to the middle of the petal. This will lighten the area and push the pigments to the edges, leaving a pretty, jagged edge when dry. Once the petal starts to dry, add a drop of Payne's grey at the root by tapping the tip of your fine brush. It is important that you allow the petal to dry off completely before adding the second one.

Name: poppy

Scientific Name: papaver rhoeas

Family: papaveraceae

Other Names: common poppy, corn poppy, corn rose, field poppy

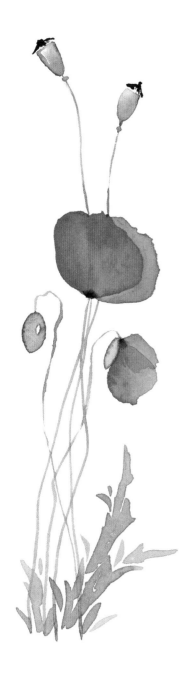

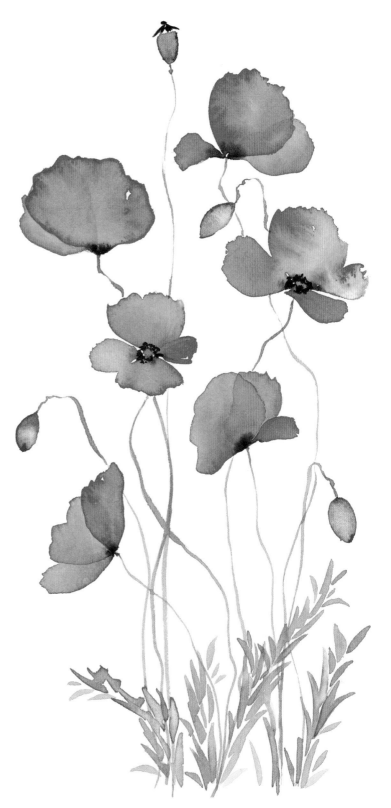

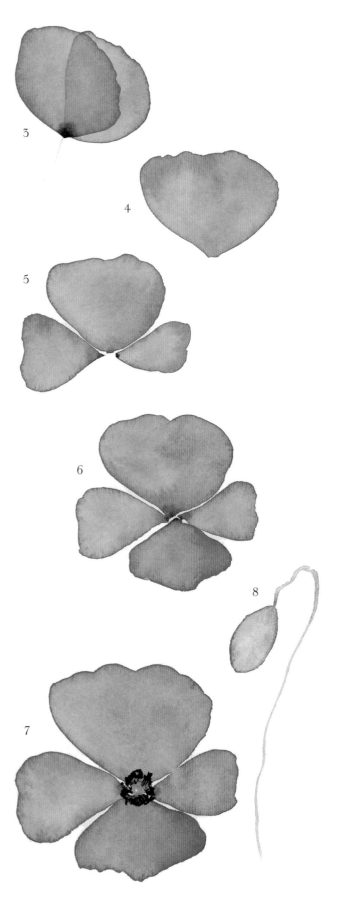

3. Use the poppy mixture again, slightly more concentrated than in step 1, to maintain good transparency. Now paint the second petal in the same way as you did for the first one.

4. Let's move on to the flowers as they are seen from the front: four petals, a heart and a crown of dark stamens. Refer to point 2 to paint the petals, starting with the petal that sits on top.

5. Continue with the slightly smaller ones on either side. Feel free to turn your page around. In my opinion, having the petal facing you makes for a prettier shape. Don't forget to add Payne's grey to the root, using the tip of the fine brush while the surface is still shiny.

6. This will make it easy to finish off the fourth and last petal. Forget about your watercolour painting for a while, so it can dry. Just enough time for a cuppa and a quick search to learn more about the magnificent "symbolism and meaning of poppies".

7. Once the flower is nice and dry, it's time to add the details. Using your fine brush, mix some opaque white with a little azomethine yellow green and make a small circle in the centre to create a pistil. Rinse your brush and paint a wreath of stamens around the pistil with tiny dots of concentrated Payne's grey.

8. The flower buds always lean towards the ground. Prepare some soft green and use the tip of your soft brush to draw the outline. Colour it in and quickly add a drop of water to lighten the middle of the bud. It's best to use a fine brush here to reproduce the effect of the poppy's delicate stems. Now, this is the one time you are allowed to let your hand shake! At this point, you can add a few buds with a spot of red to give the impression that they are opening.

9. The pods are held by a rather straight stem. They are of an "obovate" shape. That is, an oval shape that is narrower at the bottom and wider at the top. In other words, an inverted egg. Drawing a central axis in pencil will make it easier for you to align the stem, capsule and its cap. With the tip of the soft brush loaded with soft green, draw the left side of the capsule. Then, repeat the same line on the other side. Colour the inside in green. Then, using Payne's grey and the fine brush, finish off the hat with a few lines that meet in the middle.

10. The leaves bring the ball to a close. It's easy to paint these jagged, furry leaves in a series of limber brushstrokes.
11. First apply the tip of the brush, then lightly squeeze the belly as you bring the brushstroke up, and then remove the brush at the end. Repeat as necessary.

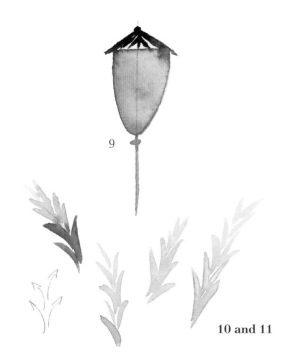

9

10 and 11

WHY YOU SHOULD LOVE THIS PLANT

Poppies have the magical power of putting smiles on people's faces in an instant. This will be followed by a sigh of contentment. Perhaps a memory from childhood, the famous nursery rhyme that whispers in our ears: "*Gentil coq'licot, Mesdames…*".

A fragile symbol of summer, the poppy doesn't like being in a bouquet. **You can give up on trying to pick** one, because its petals will have fallen off before you even get it near a vase. Its flamboyant red reveals its hypnotic power only in the wild, in the fields where it grows. That's just how it is, that's the paradox of this frail flower with its crumpled dress, yet blessed with such an intoxicating aura.

This solitary, ephemeral flower has fascinated modern painters. How can we not be reminded of the famous painting *The Poppy Field* by Claude Monet, or the works of Vincent Van Gogh, Gustave Courbet and Gustav Klimt?

Many Art Nouveau artists and craftsmen were also won over by this simple flower, which they came across on their country walks. It was abundantly depicted during this period, in glassware (Daum and Gallé vases, for example), earthenware, on small pieces of furniture and decorative components in majestic stained-glass windows.

Even today, the field poppy has become a must-have on all substrates, using all kinds of techniques. Whether it is found on wallpaper, fabric, ceramics, embroidery, etc., we see it all around. So it wasn't easy to let go of all that artistic baggage and attempt this watercolour painting. No need to panic though; in just a few brushstrokes, the fragile poppy will start to take shape, I promise!

Following in the footsteps of all these painters (some more famous than others), all these different artists who have been captivated by this splash of red at harvest time, you have created YOUR VERY OWN poppies!

Snake's Head Fritillary

EQUIPMENT

- Medium round brush
- 0.5 mm mechanical pencil

COLOUR PALETTE

Verona marble: quinacridone pink + twilight yellow

Soft green: chromium green oxide + azomethine green yellow

How to recognise it

Its flowers: 1-2 flowers per stem, stoops towards the ground, composed of 6 petals (which are actually tepals) purple with a chessboard pattern.
Its leaves: long, thin and dispersed.

Its size: 20 - 40 cm.
Its habitat: wet meadows, riparian forests.
In bloom: April to May.
Altitude: 200 - 1,200 metres.
PROTECTED PLANT

HOW TO PAINT IT

1

2

3

Your mission will be to paint a beautiful snake's head fritillary with her full, billowing skirt. With a few carefully placed brushstrokes, you'll get there.

1. Start by preparing your Verona marble colour mix. Load your round brush with this mixture, with the brush facing upwards. Form the first petal by applying the tip of the brush, then squeeze the belly as you pull the brush towards you, and finally lift it off the page. Try to give the line a slight curvature as well. Yes, I know, that's a lot of things to remember to do all at once, but after a few tries, you'll be able to do this sequence of movements with your eyes closed, whistling, and hopping on one leg!
2. Again, do the same movement alongside the first brushstroke, straight and a little shorter than the first one.
3. Make the third brushstroke identical to the first, this time with a slight curvature towards the inside of the flower. Add a drop of water to a part of your flower that is still wet in order to lighten that area, while you load another part with pigments. This technique will make the surface less dull and add contrast and character to your flower.

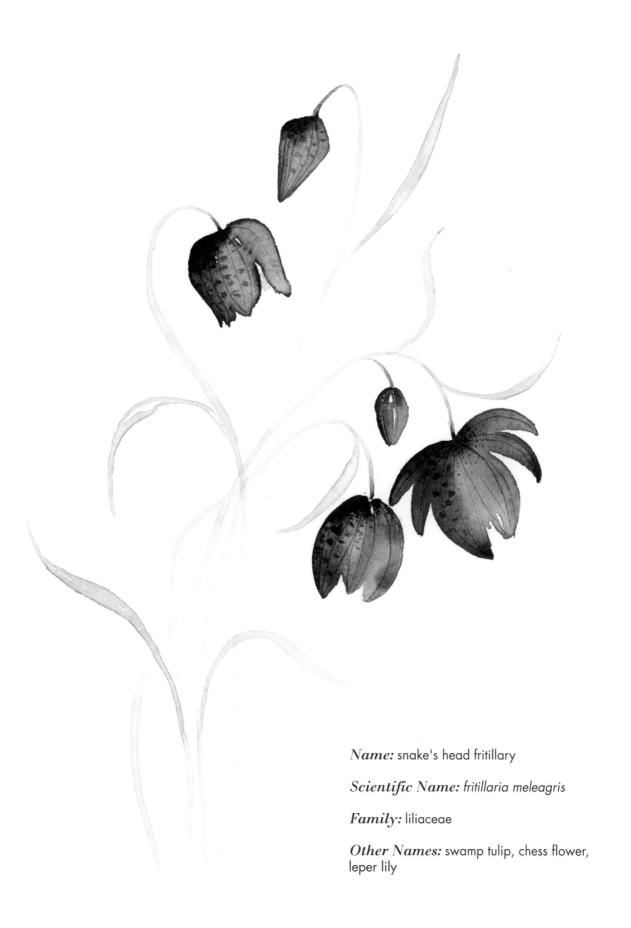

Name: snake's head fritillary

Scientific Name: *fritillaria meleagris*

Family: liliaceae

Other Names: swamp tulip, chess flower, leper lily

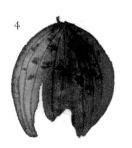

4. The fritillary's special feature is its dark chessboard pattern. I like to give the impression of this pattern by scratching the paper with the metal part of a mechanical pencil (lead retracted). The surface of the paper must still be very wet. If not, add a little water with a brush. Then scratch vertical lines that are curved slightly, following the corolla's rounded edges. Go on to scrape small, spread-out squares. There's no need to colour in the petals completely, as this will make them look too heavy. Then concentrate on the upper part of the corolla. To make the chessboard pattern even more intense, add a few dabs of the concentrated Verona marble mixture with the tip of your brush, in the area where you scraped the paper.

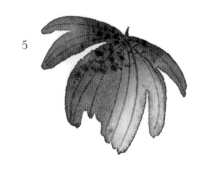

5. The process is quite similar when you paint flowers that are a little more open. Complete steps 1-4, and add another 2 brushstrokes on each side. With the brush facing upwards, starting from the upper part of the flower, do the point-to-point movement, as explained in point 1.

6. All that's left to do is to scratch the damp paper, to create that characteristic chessboard effect.

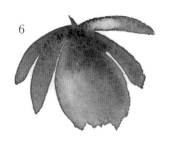

7. Gently, using the tip of the round brush, paint a few slender stems. To make the task easier for you, do the following: turn your page half a turn and, starting from the corolla, draw the stem up to the edge of your leaf. Personally, I find it easier to see what I am doing, without my right hand blocking my view. If you are left-handed, you will not need to turn your page around. Either way, try out what works best for you.

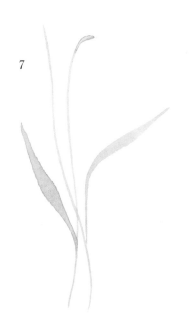

It's beautiful, you can be pretty proud of yourself! See how the snake's head fritillary can restore your confidence in your own creativity.

WHY YOU SHOULD
LOVE THIS PLANT

At the beginning of this story, a small round and white bulb sleeps in the earth. A slightly bland bulb with nothing particularly extravagant about it. Yet, it will give life to such a chic flower; its head always bowed, looking a little lonely but well dressed.

Now free of her bulb, *Madame* Fritillary is just a thin shoot. But don't be fooled! Like an illusionist, she takes care to stage her trick and divert our attention. Yes, because *Madame* Fritillary is getting herself ready.

Being the very chic flower that she is, she knows perfectly well how to make herself look beautiful. She dresses up in her most beautiful skirt – her balloon skirt, the one with the checked pattern.

Sometimes, she groups together with two or three other artists, to make the show more intense. And underneath her skirt she hides her yellow stamens, which are very rich in pollen.

Then *Madame* Fritillary will gradually dry off and raise her head.

She now covers herself with her most beautiful hat: a rather dapper beige capsule. Now its finally time for the highlight of the show. The strong wind blows, and *Madame* Fritillary opens up her hat to let her black seeds fly away. It is now clear the show has come to an end. The artist bows. Curtain… and the bulb falls asleep until next spring.

Particularly widespread in Europe about fifty years ago, snake's head fritillary would often be found along the banks of pretty streams.

But now, it has become quite rare and in some places it is even on the verge of extinction. It grows in wetlands, sometimes floodplains. Places that have been taken over by humans and transformed into diverse cultures. It is therefore highly threatened in its natural habitat and is now the subject of special attention. Relocation campaigns have been conducted. Picking this plant is strictly prohibited.

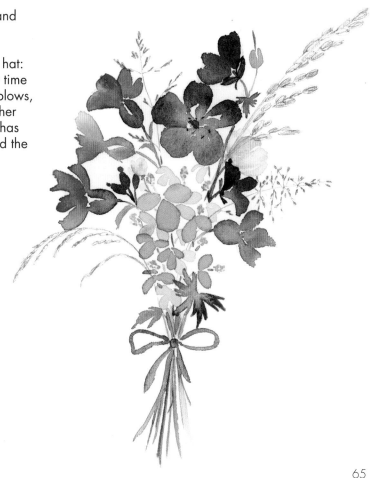

Common Comfrey

EQUIPMENT

- Fine brush
- Medium round brush
- Large flexible brush
- Pencil
- Eraser
- 0.5 mm mechanical pencil

COLOUR PALETTE

< with more mauve

Purple:
mauve + perylene
red deep

*< with more
perylene red deep*

Slate:
chromium
green oxide
+ bluish purple

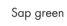

Sap green

How to recognise it

Its flowers: a cluster of small flowers, lilac to purplish red (sometimes light yellow), bell-shaped. The stems are long, hollow and furry.

Its leaves: long leaves with a straight edge. The plant is very bristly, with stiff hairs all over it.

Its size: 40 - 120 cm.
Its habitat: edge of streams, wet meadows, ditches, forests.
In bloom: May to August.
Altitude: 200 - 1,000 metres.

HOW TO PAINT IT

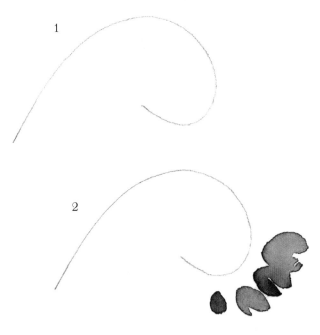

1. Using a pencil, start by drawing the coiled shape of the stem that will eventually carry the clusters of purplish flowers.
2. Prepare two different purple blends. The first one tending a little more towards red and the second, a little more towards purple.
 These two blends will allow you to have fun varying the shade of the bells. Load your round brush with these diluted mixtures. Make sure to leave half a centimetre free between the flowers and the stem. Paint two brushstrokes, first placing the tip of the brush at the top, then squeezing the belly as you go down. Paint several flowers side by side.

Name: common comfrey

Scientific Name: symphytum officinale

Family: boraginaceae

Other Names: ox tongue, donkey ear, blackwort, slippery root

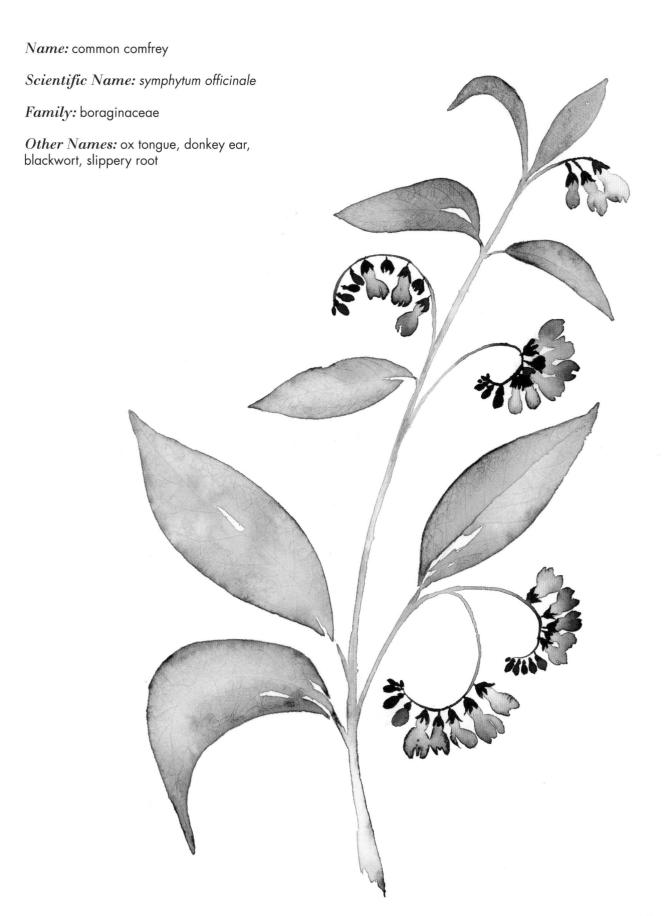

3. Rinse your brush out, so that you can paint the base of the corolla using water only. The pigments in the previously painted area can then fuse together. When the flowers start to dry, you can add another drop of clean water. The pigments will then sink down to the base of the petals, creating a pretty purple gradient.
4. Now use your fine brush loaded with concentrated blends of purple to paint buds that gradually get smaller. Paint all of the flowers, then leave them to dry.
5. Once all of the clusters are dry, add the calyxes with the fine brush, using the concentrated slate mixture. Use the same mixture for the tip of the stem, then continue with the round brush, this time loaded with sap green.

HOW TO PAINT ITS LEAVES

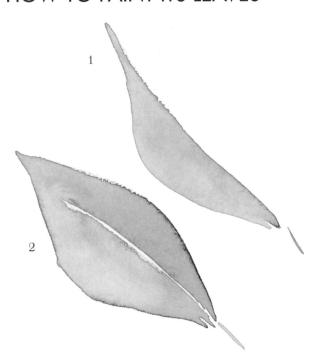

1. The leaves are an important part of the comfrey. There are many of them and they are quite large and dominating. Then use the large, soft brush to paint with diluted sap green. The left part should be elongated.
2. Do the same with the right side. Remember not to colour everything in; leave patches of white paper. This will make your leaves much more interesting.

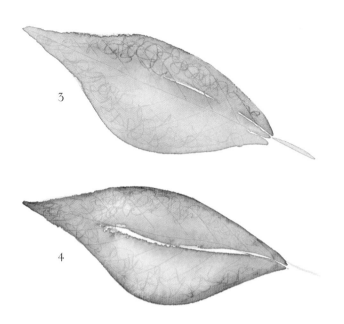

3

4

3. Comfrey leaves have countless veins all over them, giving them an embossed appearance. You can easily reproduce this effect by scratching the wet paper with a mechanical pencil. Use the metal part, with the lead retracted. Start by drawing the midrib and secondary veins, then do some squiggles in the figure of an "8".
4. Be quick! Is it still wet? No? Don't panic! You can add your very diluted sap green mixture evenly over the entire comfrey leaf. Yes? Then accentuate the edge of the leaf by adding concentrated sap green directly from the pan, using the tip of a fine brush.
 I would advise you to do one leaf after another, so that you can paint with complete serenity.

WHY YOU SHOULD LOVE THIS PLANT

Because of its large size, it is often referred to in France as the "grande consoude". And what a delight it is to watch the bees feeding inside the deep flowers of this melliferous plant.

Like arnica, comfrey is known to be an excellent remedy for ligament and tendon injuries. Used as a poultice, it helps to relieve congestion and heal haematomas. Comfrey-based ointments are the most widely used remedy for sprains. Due to certain substances that are harmful to the liver, however, this tall, slender plant should not be consumed.

Comfrey has the ability to draw trace elements directly from the soil and store them in its leaves. Thanks to this phenomenon, its leaves make an

extraordinarily good garden fertiliser. This vegetal treasure is more effective than any chemical fertiliser, as the minerals can be fully assimilated by your vegetables. When planting tomatoes, potatoes, etc., simply place a comfrey leaf directly inside the hole, add a little soil and then plant on top. The comfrey leaf will give your plants a kick-start!

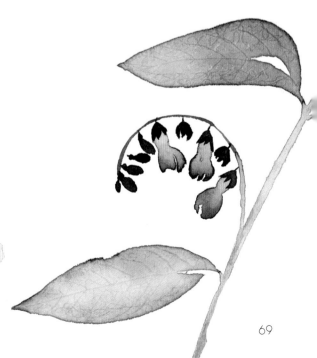

Brilliant!
Two mixtures, a lovely
shade of green, a dash of ingenuity,
a few doodles and little by little,
your beautiful comfrey appears!

Common Mallow

EQUIPMENT

- Fine brush
- Medium round brush
- Watercolour pencils (optional)

COLOUR PALETTE

Mallow:
mauve
+ quinacridone
pink

Frog:
Twilight yellow
+ light azo
yellow

+ bluish purple

Twilight yellow

Opaque white

How to recognise it

Its flowers: delicate and fragile, mauve in colour, formed by 5 petals that are narrower at the base, dark pink-mauve veins. In the centre of the flower, the stamens are fused together to form a sort of tube, which is characteristic of the malvaceae family.

Its leaves: furry and shaped like a hand.
Its size: 40 - 120 cm.
Its habitat: roadsides, banks, scrub, hedges.
In bloom: June to September.
Altitude: 200 - 1,200 metres.

HOW TO PAINT IT

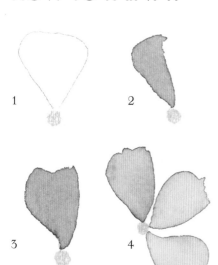

1. To help you position the flowers and visualise the five petals around them, start by drawing the centre of the flower with a pale pink watercolour pencil. Looking at the characteristic shape of the petals, you can see that they are triangular and well spaced out.
2. Using the round brush and the diluted mallow mixture, form the left-hand side of the first petal without touching the centre, starting with the tip of the brush and then squeezing the belly in an upwards movement.
3. Do the same for the right-hand side of the petal.
4. Once you have painted several petals, add a little water to the middle of the petals, using another brush loaded with clean water. This will lighten the area and push the pigments to the edges, giving them a pretty, jagged edge when dry.

Name: common mallow

Scientific Name: malva sylvestris

Family: malvaceae

Other Names: cheeses, high mallow, tall mallow

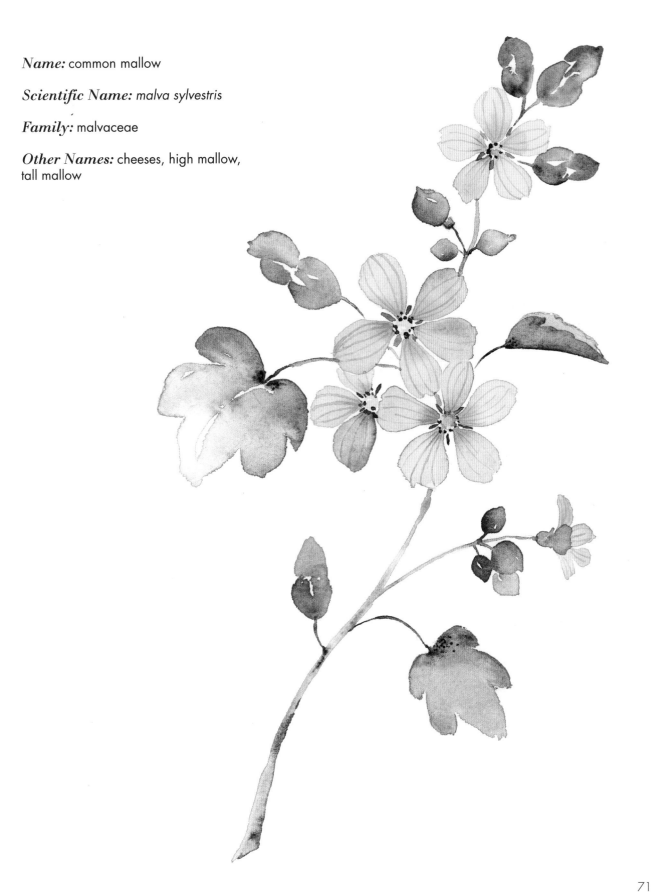

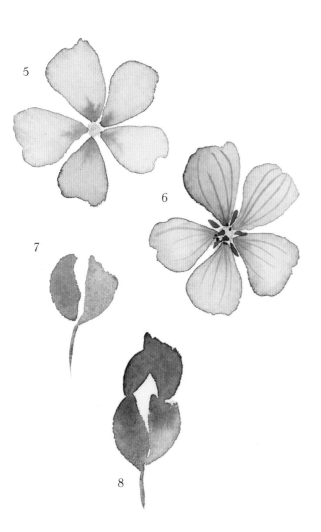

5. When all five petals start to dry, drop a hint of bluish purple at the root of each one.
6. Once the flower is nice and dry, it's time to add the final details with the fine brush:
 • Draw thin veins using your mallow mixture, but this time make it a little more concentrated;
 • Add the green sepals between each petal;
 • Add some opaque white to the central part, which will bind with the watercolour pencil (add a touch of yellow if necessary), to create a pistil.
7. The buds are painted in the frog mixture that was also used for the receptacle.
8. Then add the more pigmented mauve mixture, allowing the colours to merge.

HOW TO PAINT ITS LEAVES

1. Now for the leaves: draw the midrib line with a green watercolour pencil. This will allow you to imagine where and which way around the leaves will be. The common mallow has heart-shaped leaves.
2. Still using the round brush, this time with the frog mixture, quickly draw the left-hand edge of the leaf from the tip downwards, pressing down with the brush.
 Do the same for the right-hand side, trying to recreate the same shape.

3. Add a little yellow twilight in places, such as at the base of the stem, so that the pigments diffuse into the still-moist area. Once the leaves are dry, you can use twilight yellow to add the finishing touches, if you wish.
In nature, the mallow's leaves are often spotted or perforated.

3

WHY YOU SHOULD LOVE THIS PLANT

Its delicate petals, which are sometimes beautifully crinkled, make it so elegant.

With its long stems dotted with flowers and buds (called *fromageons* or "mini-cheeses") that sway in the wind, mallow is in itself the name of a soft colour.

Known for its expectorant properties, common mallow is used in cough syrups.

The wild mallow blooms generously until autumn. It can easily be sown in our gardens, giving a romantic and very English look to borders or flowerbeds.

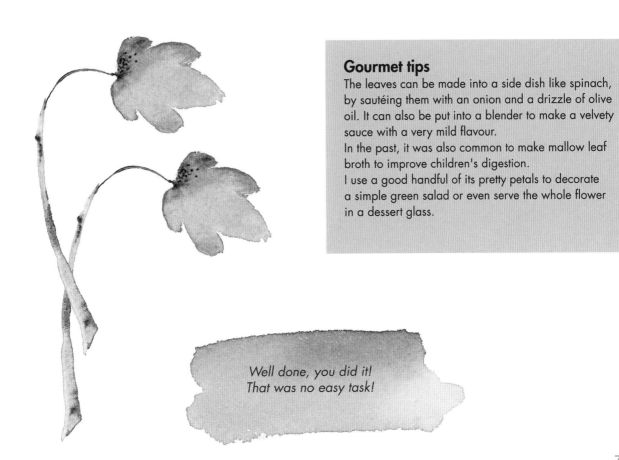

Gourmet tips
The leaves can be made into a side dish like spinach, by sautéing them with an onion and a drizzle of olive oil. It can also be put into a blender to make a velvety sauce with a very mild flavour.
In the past, it was also common to make mallow leaf broth to improve children's digestion.
I use a good handful of its pretty petals to decorate a simple green salad or even serve the whole flower in a dessert glass.

Well done, you did it!
That was no easy task!

Field Scabious

EQUIPMENT

- Fine brush
- Large flexible brush
- Pencil
- Eraser
- Pigma Micron fineliner 01 cold grey

COLOUR PALETTE

 Mauve

 Chromium green oxide

How to recognise it

Its flowers: bluish-violet, in the shape of bristly half-pompoms called capitula, the plant is furry all over.
Its leaves: opposed, grey-green in colour, they can take a variety of shapes and are usually jagged.

Its size: 30 - 90 cm.
Its habitat: meadows, roadsides, woodland edges, embankments.
In bloom: May to September.
Altitude: 200 - 2,000 metres.

HOW TO PAINT IT

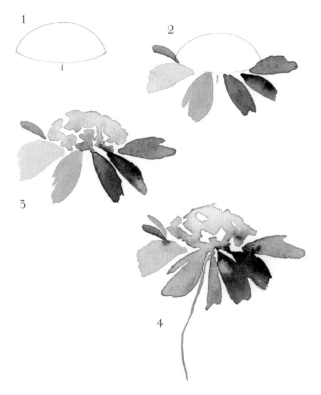

1. Draw the half-pompoms with a pencil, without pressing down too hard on the outlines. You can then use the large soft brush for the whole plant.
2. As we can see, the petals around the edge are more elaborate than those in the middle. Load your large soft brush with the medium diluted mauve colour. In one movement, apply the tip of the brush and then slightly squeeze the belly. Don't try to create shapes that are too regular, just let the brush do its thing.
3. With the tip of your brush, fill the middle with randomly shaped lines. Don't forget to leave some white, which is essential for creating a natural looking flower.
4. Add a drop of water to the top of the flower. This will create a mauve shade by pushing the pigments downwards. Enjoy painting some of the sepals as well as the stems with chromium green oxide. If you do it quickly, the green will merge nicely with the purple in places.

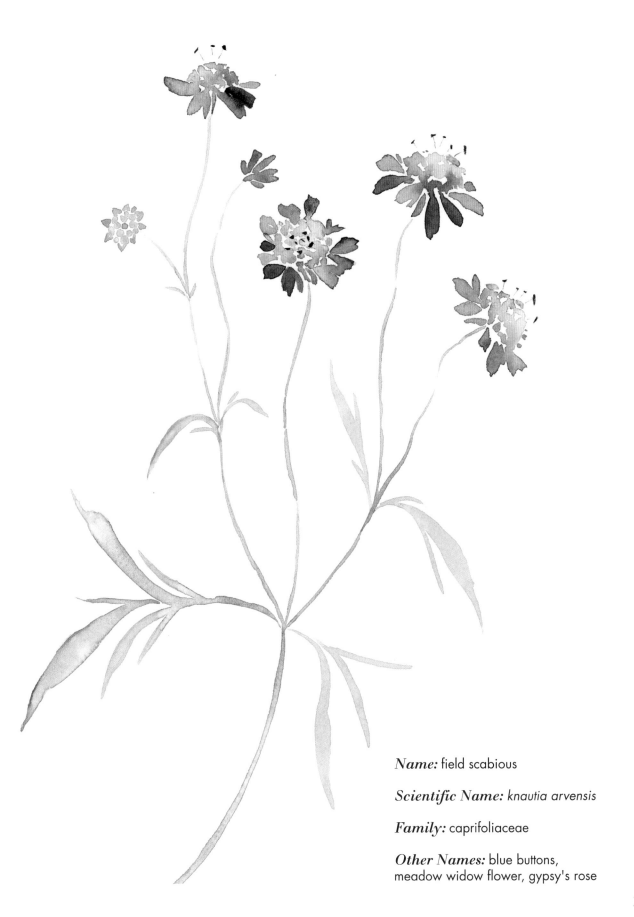

Name: field scabious

Scientific Name: knautia arvensis

Family: caprifoliaceae

Other Names: blue buttons, meadow widow flower, gypsy's rose

HOW TO PAINT ITS LEAVES

1. To simply suggest the leaves of the field scabious, start by moving the tip of the brush towards the stem, then squeeze the belly while pulling the brush towards you in a long, slow movement. The leaves are arranged opposite each other, always at an intersection of stems.
2. Finish off by drawing lines of varying lengths to the left and right of the leaf.
3. Field scabious leaves can take various forms; here are some ideas.
 Have fun making them dance!

Using a fineliner pen or fine brush, draw the little lines above the flowers (stamens). Finish with highly pigmented purple lines to form the anthers.

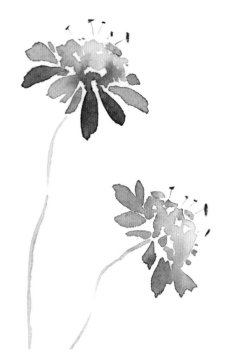

WHY YOU SHOULD LOVE THIS PLANT

It is a wild plant with simple charm. To my astonishment, I could find little information about the different scabious species. Despite all the books on botany I have, these plants are clearly of little interest to researchers. They are not useful enough to be counted among medicinal plants, nor are they of any culinary interest in order to be included in books on edible wild plants.

It's a real shame, because I think it's such a lovely plant.

If you ever get the chance, pick a flowering stem and hold it between your fingers. Rotate it slowly, the furry stem often has a characteristic curve to it. If you look at the underside, the part around the base of the flower, you'll see pointed green bracts arranged in an

attractive star shape. Now take a look at what looks like a violet half-pompom. It is actually **a bouquet of several dozen tiny flowers.** Before your very eyes is a kind of super flower! The flowers in the centre are much smaller, while those around the edges are particularly well formed.

The role of the latter is to attract insects, while those in the centre are where seeds are grown. Imagine you are a bee, flying low and a little hesitantly. You are spoilt for choice and then you see a beautiful field scabious. Relieved, you take a rest on this fuzzy blue-violet cushion. What a joy it must be to experience this kind of pleasure!

For me, this flower is synonymous with Corpus Christi, because it is at this time of year that we collect large bouquets of field scabious, globeflower (now almost extinct), daisies and sage. We would arrange them in cream cans, jugs or large stoneware pots, which were used to decorate the front of houses for when the procession passed by. The flowers that remained in the fields were mown for fodder soon after.

You have to admit, you can't help but marvel at a bouquet of field scabious complemented by a few daisies. This is the ultimate romantic country bouquet.

Found growing everywhere, this beautiful wildflower is **a typical feature of natural grasslands that are well balanced in terms of water and organic matter.**

Dairy cows love it. It's a good thing, too, because field scabious contributes to the flavour of some of the best cheeses.

*Well done,
you've painted dancing leaves
and purple pompoms!*

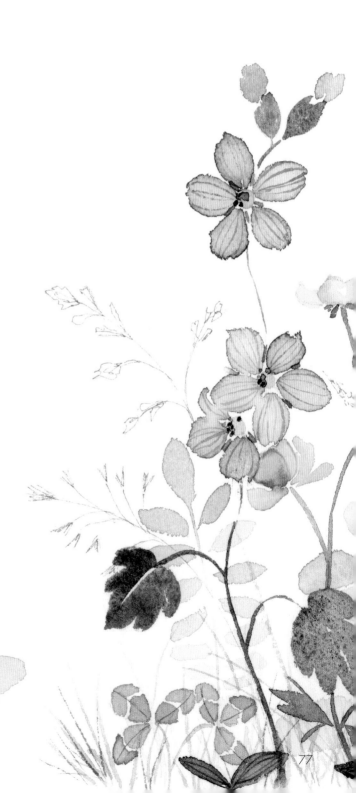

Harebell

EQUIPMENT

- Fine brush
- Medium round brush
- Pencil
- Eraser

COLOUR PALETTE

Bluebell:
indanthrone blue
+ bluish purple

Sap green

How to recognise it

Its flowers: 5 gathered petals, shaped like a flared bell, purply-blue in colour, the flowers are generally found in clusters.
Its leaves: the rounded base leaves that are arranged in a rosette disappear once the flowers bloom. Thin, elongated leaves are distributed over the rest of the smooth stem.
Its size: 10 - 50 cm.
Its habitat: meadows, moors, open woodland, rocky outcrops.
In bloom: June to October.
Altitude: 300 - 1,500 metres.

HOW TO PAINT IT

1. Before you apply any watercolour paint, draw a pencil sketch of the stems and offshoots. These lines will form the framework of your artwork. You can paint the bells and buds dangling from the end of each one.
2. Take pleasure in admiring the sublime shade of blue obtained by mixing indanthrene blue and bluish violet. Prepare a fairly diluted mixture and load a good amount of it in your round brush. However, keep back a little of this highly pigmented mixture in a corner of your palette for use in step 5. Apply the tip of your brush in a downwards position. Following this, squeeze the belly of the brush as you guide it upwards, then take the brush off the page.
3. Then draw two "V" shapes next to each other.
4. As your first brushstroke in point 1 is ascending, the next stroke will be descending. With the brush pointing upwards, first apply the tip, then the belly of the brush, moving downwards, and finally lifting the brush upwards to create a pretty curved point.

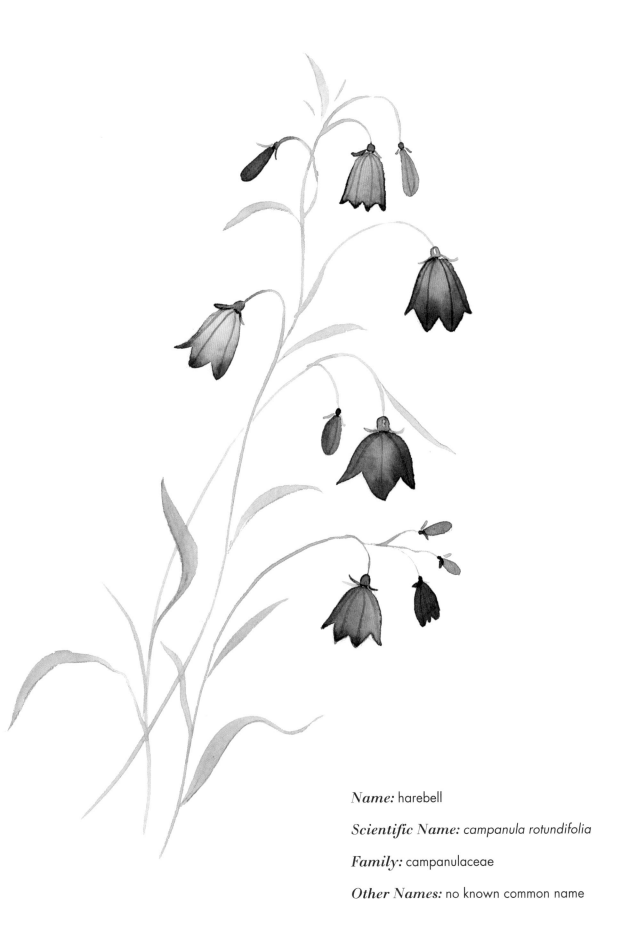

Name: harebell

Scientific Name: campanula rotundifolia

Family: campanulaceae

Other Names: no known common name

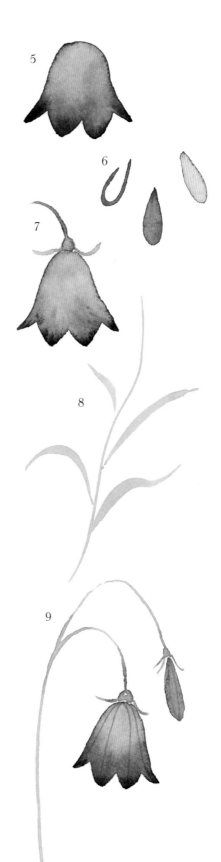

5. It's time to colour in the bell, starting at the bottom. Give your brush a quick rinse, then finish off the upper part of the bell using slightly pigmented water. Using the fine brush loaded with a highly pigmented harebell blue mixture, add a few dabs to the tips of the petals. Rather than using a flat colour, this enhanced contrast will give a more natural, charming and voluminous look to the bells.

6. For the buds, start by painting their outline with the tip of the round brush. All you have to do is colour them in. Make sure the paint is completely dry before you continue, because you'll need to be able to make nice flowing brushstrokes without fear of smudging your work.

7. Add the calyx in sap green.

8. Gently, with the tip of the round brush, paint some slender stems. I think it's more practical to do it this way: turn your sheet of paper around by half a turn and, starting from the calyx you've just painted, draw the stem at the edge of your sheet. Personally, I find that my view is less blocked by my right hand holding the brush, and the contact with the flower is more precise. If you are left-handed, you will not need to turn your page around. Either way, try out what works best for you. Then join long, thin leaves to the flower using the tip-belly-tip move.

9. To conclude, here are the little details that make all the difference! These lines were drawn with a fine brush, using the harebell mixture. Starting at the bottom of the flower, they join at the top of the bell. In my opinion, the best thing to do is to use paint that has dried out slightly in your palette; dip the fine brush into paint that is just a little bit damp, or has been sponged dry.

WHY YOU SHOULD LOVE THIS PLANT

First, let's dissect its scientific name: *campanula,* derived from the Latin *campana,* meaning "little bell", in reference to the shape of its corolla, which makes obvious sense. *Rotundifolia*: *rotundus* meaning "round" in Latin and *folium* meaning "leaf". When you look at its round leaves, this also makes perfect sense. Well, no actually! Because if you approach what you think is a clump of Campanula, look at its base, and even push the intertwined grasses aside, well, there's often nothing there! There are no rosettes of round leaves as the etymology suggests! So, are we mistaken? Perhaps this is the harebell? It's easy to get mixed up, because the Campanula genus encompasses around 300 different species!

Moreover, many of them are native to the mountains of Central Europe.

And yet: the colour, the clusters of dangling bells, the spindly stems, that ingenuous "I'm beautiful but I don't know it" quality, it all fits the bill! So why are there no round leaves, one of the distinctive features of this wild beauty? And what's with all these long, thin leaves? This mischievous plant distinguishes itself from all other species of harebell by the fact that it has two types of leaf: rounded basal leaves and its almost lanceolate leaves on the stem.

Let's pick up the story from the beginning. It's springtime, rosettes of rounded leaves are starting to emerge. Then, a number of very thin but sturdy stems weave their way through. As the days and nights go by, raised buds start to appear. They gracefully lower their heads to face the ground as time plods slowly on. Now they unfurl to reveal magnificent bluebells suspended in the air. And then, just like in a magic show, the magician enters the scene... and poof! The rosettes of leaves disappear from the base, while another layer of thin, linear foliage starts to grow from the lower part of the stems! All that is missing is a puff of smoke, applause and whoops coming from the audience. Bravo! Encore! But no, the modest Campanula performs her trick with the same indifference as the people who walk on by. These second, slender leaves will remain green until late in the autumn.

The harebell's long blooming period means that it is just as much at home in a natural flowerbed, on an embankment, in a rockery or on a balcony, in the company of other pretty wildflowers such as the cornflower, mallow, fennel, scabious, sage, chamomile or lady's mantles, for example. Some garden centres have had the good idea of expanding their wildflower range. They have the advantage of being very easy to look after. Like many mountain plants, the harebell is able to survive droughts by burrowing its roots deep into the soil.

The best time to contemplate the pretty bells is just after the rain or in the morning when dew drops glisten and bead along the blue corolla; for me, it is always a moment of pure delight.

Bravo!
You have created a mixture
that is both vibrant and natural looking.
You've seen how easy it is to paint
a complex-looking flower!

Woodland Geranium

EQUIPMENT

- Fine brush
- Large flexible brush
- Watercolour pencils
- Masking tape

COLOUR PALETTE

 Chromium green oxide

 Payne's grey

 + bluish purple

 Twilight yellow

 Opaque white

How to recognise it

Its flowers: purply blue, composed of 5 rounded and spread out petals.
Its leaves: deeply jagged. The whole plant is similar to the meadow geranium, but its leaves are slightly more dispersed.

Its size: 30 - 60 cm.
Its habitat: wet wasteland, meadows, fertile and wet soil.
In bloom: May to July.
Altitude: 400 - 2,300 metres.

HOW TO PAINT IT

Add a little charm to this composition by creating a shadow to frame the bottom left corner. To do this, stick two strips of masking tape onto the edges of the bottom left corner. Make the tape a bit less sticky by sticking it onto your clothes first. Then brush on very diluted chromium green oxide.

1. While it dries, visualise the shape of the geranium flower. It has five rounded petals. Make it easy on yourself by drawing a central circle with a green watercolour pencil. Then arrange five lines in a star shape to define the centre of your five petals.
2. Prepare some bluish violet watercolour paint.
 Using the tip of your large soft brush, draw the outline of your petals with this violet colour, using the green line as a guide.

Name: woodland geranium

Scientific Name: geranium sylvaticum

Family: geraniaceae

Other Name: wood cranesbill

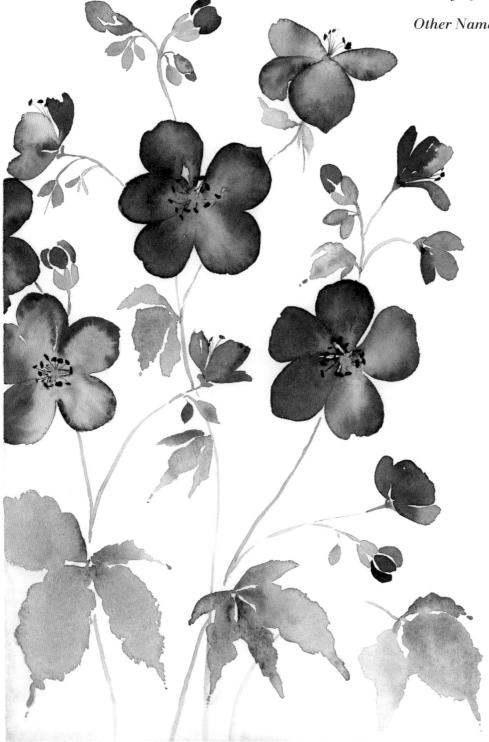

Masking tape

3. Colour the petal in with the bluish violet paint. Do the same for the other four petals.
4. You will be able to take advantage of the still damp surface to lighten the middle of your flower. Dab some very diluted chromium green oxide at the base of each petal. Admire how the pale green merges with the violet of the petals.
5. When the five petals start to dry, apply concentrated bluish violet directly from the pan around the edge of each one. The aim is to further intensify the colour. I recommend using the fine brush for more precision.
6. The flowers that haven't opened up as much are painted in the same way as the petals described in point 2, the only difference being that you should arrange them in the shape of a bowl. Leave to dry.

HOW TO PAINT ITS LEAVES

1. Now let's move on to the leaves of the woodland geranium. They are deeply incised and rather serrated. You will be able to recreate them easily with descending zigzag movements of your brush. Use the belly of your large soft brush, generously loaded with chromium green oxide.
2. Do the same for the other lobes. Also remember to sprinkle the still-moist green with twilight yellow. It's time to gently remove the masking tape. Let your watercolour painting dry.

3

3. Once the flowers and leaves are dry, you can add the final details using the fine brush:
- Draw the stamens with concentrated Payne's grey.
- Add calyxes, buds and stems, all in chromium green oxide.
- Add opaque white to your green, and use this mixture to paint a circle in the centre.

While you were painting, you discovered a secret. A dialogue between nature and watercolours. Petals with intense colours that stir one's heart and soul.

WHY YOU SHOULD LOVE THIS PLANT

Above all else, the woodland geranium is characterised by its colour.

Like the poppy's red colour and the buttercup's yellow, it is its intense colour that defines the woodland geranium's identity and catches the eye. But it's not just any old colour. It is a flamboyant, mesmerising, purply blue. The same goes for his brother, the meadow geranium.

Its five petals open wide to reveal their delicately perfect contours. These petals are nicely rounded and spread out just enough to show off the pistils and stamens. Just a hint of slightly crumpled petals for a perfect balance.

And if you take the trouble to look at the flower in the sunlight, pearly pink hues will be revealed as though it were made of a luxurious fabric, such as organza voile. In the middle is a shade of pale green, which shows off the stamens even more.

I enjoy contemplating this wild beauty, with its exquisitely shaped leaves and stems that intersect, intertwine even, giving it even more presence.

And towards the end of the flower's life, its petals will fall gracefully to the ground, one after the other.

At this stage, we can marvel at the geranium's aesthetically pleasing bare corolla.

When they reach maturity, the seeds are propelled as the fruit bursts open.

I am fortunate enough to have some magnificent woodland geraniums brightening up my garden for much of the summer.

A meadow plant in the garden
I gleaned a few seeds years ago and put them in pots the following spring to replant in the garden. Since geraniums are perennial, they reappear every summer as an upright clump. In the autumn, a pleasant surprise comes in the form of its leaves, which take on a magnificent bronze colour with a few hints of red. If you have a small, fertile and shady corner of your garden available, have a go at planting some geraniums.

Water Avens

EQUIPMENT

- Fine brush
- Medium round brush
- Large flexible brush
- Pencil
- Eraser

COLOUR PALETTE

 Light azo yellow

 Chromium green oxide

 Quinacridone pink

 Burgundy: perylene red deep + Payne's grey

How to recognise it

Its flowers: it can easily be recognised by its flowers perched on a dark and furry stem. These flowers have five or six pale yellow petals hidden under a sort of bell that is formed by dark purple sepals.
Its leaves: numerous furry and jagged leaves growing in a cluster.
Its size: 20 - 60 cm.
Its habitat: marshy forests, stream banks, wet meadows.
In bloom: April to July.
Altitude: 300 - 2,000 metres.

HOW TO PAINT IT

1

Just this once, start with the leaves. You can use overlapping and transparency to create the effect of lovely big leaves.

1. Prepare some heavily diluted chromium green oxide. Use the large soft brush, load it with your very diluted green. Outline the three-lobed leaves using the tip of your brush and then paint the inside of the leaves in a single colour. This first coat must be diluted enough to allow the other two concentrations to be layered on top. If your first layer of leaves seems too dark, and while your watercolour is still wet, you can add a drop of water, which will push the pigments to the edges and lighten your leaf. You can also use a tissue, laid flat, to blot the excess paint before redoing this area with very diluted paint. Allow it to dry.

Name: water avens

Scientific Name: geum rivale

Famille: rosaceae

Other Names: nodding avens, drooping avens

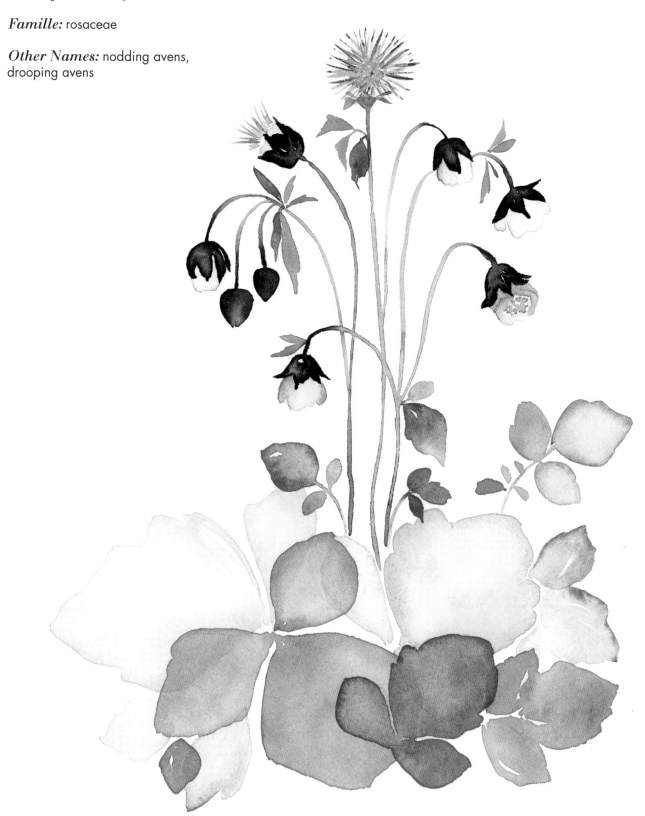

2

2. Once the first coat is completely dry, move on to the second layer of foliage, this time using a slightly less diluted chromium green oxide than before. Allow it to dry.
3. Once your second coat is dry, go on to the third layer of leaves, still using the same technique, but this time your brush will be loaded with fairly concentrated chromium green oxide.
4. Let's move on to some shy flowers now. To help you arrange the flowers harmoniously, start by lightly drawing out the stems in pencil.
 For the water avens' pretty pale yellow bells, use the round brush and the light azo yellow paint. Using a series of downward strokes, you can form the flower's corolla. To embellish the petals, use the tip of the fine brush to add quinacridone pink to the edges. Leave to dry.

3

4

5

5. It's time to add the finishing touch with the large burgundy calyxes, which create a nice contrast with the pale yellow petals. Prepare your magnificent burgundy blend. As in point 4, use the round brush and, using a series of downward strokes, form the calyx, either in the shape of a bell or more open. Take advantage of the fact that the burgundy paint is still wet to continue painting the stems with the same mixture, but more diluted.

WHY YOU SHOULD LOVE THIS PLANT

Ahhhh water avens...
They may not be the brightest of flowers, they're no match for buttercups or poppies and they don't have the rosehip's romantic charm. Neither do they have the therapeutic virtues of their cousins the wood avens, nor do they have the culinary appeal of wild garlic.

But ever since I was a little girl, I have had a special place in my heart for this rather different flower. She looks so shy, her head always facing down. It grows peeping out between its broad, three-lobed leaves. But to anyone who takes the trouble to find it, it reveals its mesmerising colour: dark red. Its buds look like tasty treats. Then, when its burgundy corolla opens up, it reveals pale yellow petals with shades of coral. Later, when the flower has reached maturity, the seeds will escape from the sepals and transform into a ball shape, like a fireworks display.

Its talent? If you come across it, have a good look around you. Water avens may be somewhat reserved but they are so clever! They know how to choose the most idyllic settings in which to grow, such as the banks of countryside streams.

Keep the momentum going.
You have managed to transcribe the natural
elegance of this wild plant.
Water avens no longer hold any
secrets for you.

St. John's Wort

EQUIPMENT

- Fine brush
- Medium round brush

COLOUR PALETTE

Light azo yellow

Azomethine green yellow

Yellow ochre

Pond: chromium green oxide + cobalt blue

How to recognise it

Its flowers: composed of five yellow asymmetrical petals, the flowers have many stamens. The stem is upright and splits into several branches.
Its leaves: opposing and oval in shape.

Its size: 30 - 100 cm.
Its habitat: roadsides, open woodlands, sunny meadows.
In bloom: July to September.
Altitude: 200 - 2,200 metres.

HOW TO PAINT IT

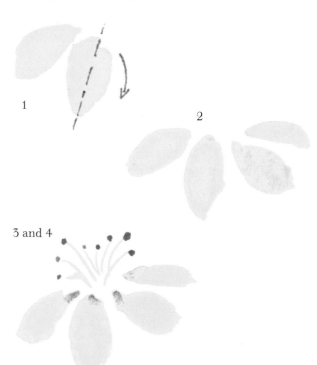

1

2

3 and 4

1. Start with the flowers: five asymmetric yellow petals. As we are going to paint the flower in profile, we will have to paint only four petals, imagining that the fifth is hidden behind them. So load your round brush with the yellow, then form the first central petal by applying the tip of the brush and squeezing its belly as you pull it towards you, before lifting it off the page. Do a similar brushstroke alongside the first to form the other half of the petal.
2. Paint the other petals in the same way, arranging them in a fan. You can add a hint of azomethine yellow green to the root of each one.
3. Create groups of three or four flowers close together.
4. Its many long stamens are a typical feature of St. John's wort. Using the fine brush, lightly sketch these in concentrated light azo yellow. Make it look like they're bursting out from the central stem. Add a few little circles at the top of each of these lines, using barely diluted yellow ochre.

Name: st. John's wort

Scientific Name: hypericum perforatum

Family: hypericaceae

Other Names: perforate St. John's wort,
tipton weed, goat weed, enola weed

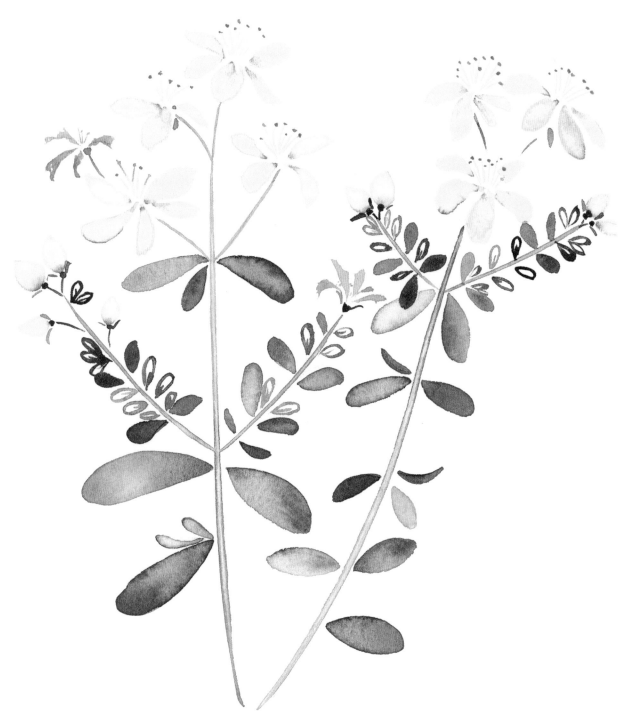

5. Prepare a large quantity of the pond green mixture, which will be used to paint the stems as well as all the leaves. Using the tip of your round brush, paint fairly stiff stems extending out from your flowers and pointing towards the foot of the sheet of paper. Also paint some branches for the flower buds and small leaves. Let it dry so that you will be able to move more freely when you do the next step.

HOW TO PAINT ITS LEAVES

1. St. John's wort has numerous, oval-shaped opposing leaves. To easily replicate their beautiful curve, place the front of the round brush on the leaf and guide it upwards. Once at the top, apply less pressure to the brush, so that you paint only with the tip. Draw the outline and go down, applying a little more pressure. Colour in the leaf.
 Paint several leaves, trying to vary the concentrations of green. This beautifully grainy pond green mixture creates a lovely texture.
2. For the branches, paint a few smaller leaves, facing each other just like the others. To lighten the overall effect, it's a good idea to do a few of them in a single stroke, using the tip of a fine brush.
3. For the flower buds, nothing could be simpler. Paint a yellow oval shape, add a drop of water in the middle to push the pigments towards the edges, then a hint of azomethine yellow green at the base. Finish off with the calyx and two small sepals in pond green.
4. Finally, to paint flowers at the end of their blooming period, use a fairly concentrated yellow ochre.

If, like me, you find your stems look a bit too dark or feature too prominently in the composition, one trick is to draw a line down the middle of the stem, in opaque white.

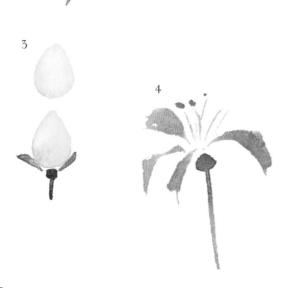

*Well done,
you captured the light and
brought it onto the page!*

WHY YOU SHOULD
LOVE THIS PLANT

St. John's wort fascinates me... He calls out to me, because every time I see him, he always seems to exclaim, as if he wants to whisper in my ear: *"Come to me... here I am, I can heal you... let me shine."* I can rarely stop myself from taking a closer look.

I start by crumpling up a flower from the St. John's wort plant between my fingers, turning them purple. Then I close my eyes, bring the flower to my nose, and concentrate on the delicate scent that emanates from it. Exactly the same smell that caresses your nostrils when you walk through the door of a florist. Such a pleasant but indefinable odour.

A delightful blend of olfactory subtleties: foliage, floral notes, aromatic elements, moss and joy. A simple pleasure. If only we could put that smell in a bottle!

St John's wort really fascinates me, because the whole plant seems to be closely linked to the sun. For me, St. John's wort is a gatherer of light.

Its habitat: it likes to grow and proliferate in dry places that are exposed to a lot of sunshine.

Its place in folklore: it is the plant of the summer solstice. For the Celts, this plant had protective powers. It brought peace and prosperity to the home, ensured abundant harvests and kept the animals in good health. Being a healing plant, the Celts carried it with them on the eve of the solstice. For the ancient Germanic peoples who practised the solstice cult, St. John's wort also played an important role. Its shape and colour reminded some people of the sun, while others saw it as a bearer of light.

Its leaves: pick a leaf and look at it with the sun behind it. You will discover that it has hundreds of small holes. As its name suggests, perforate St. John's wort or hypericum perforatum in Latin, it has leaves that appear to be perforated with small holes.

Its flowers too: St. John's wort flowers can be used to make an oily macerate, also known as red oil. It has been in use for over 2,500 years. The red pigment contained in the plant, hypericin, is a compound with anti-inflammatory, antiseptic, healing and mood-stabilising properties. The list of medicinal properties of this flower of the sun, used both internally and externally, is long.

Its uses: whether it is used to make an oil or a tincture, the plant must macerate for three weeks in the sun to reveal all its active ingredients.

However, use with caution: St. John's wort is photosensitising (it increases the skin's sensitivity to solar radiation)! So don't sit in the sun for long if you're taking it orally or applying it topically, as you may be more susceptible to sunburn. Quite puzzling really, when this plant is known for treating wounds and burns.

St. John's wort oil

Ideally, harvest the flower bud just before it opens, or when the flower has just blossomed; preferably in dry, sunny weather.
You can also harvest them a bit at a time, when you go on walks. Pick some of the flowers and leave them to dry off for later use, once you have enough of them.
Preparation
Store the fresh or dried flowers (approx. 50 grams) in a large jar.
Cover the flowers with organic 1st cold-pressed olive oil or linseed oil (200-250 ml). The oil must cover all of the flowers entirely.
Screw the lid on the jar tightly and leave it in the sun to macerate for three weeks. The oil will gradually take on a beautiful pink to red colour.
Filter the liquid through a thin cloth, squeezing it to collect as much oil as possible.
Optional: to preserve the oil, you can add 4-6 drops of real lavender essential oil + 8 drops of vitamin E per 100 ml of macerate.
Store this red oil in opaque bottles and away from light.

Dandelion

EQUIPMENT

- Medium round brush
- Fine brush
- Large flexible brush
- Pencil
- Eraser
- Pigma Micron fineliner 01 cold grey

COLOUR PALETTE

 Light azo yellow

 Dark azo yellow

 Chromium green oxide

 Azomethine green yellow

 Cankerwort green: sap green + bluish purple

 Vandyck brown

How to recognise it

Its flowers: composed of a hundred bright yellow tongues (called ligules). The stem is long, smooth and hollow. Once mature, the fluffy pappus detach from the receptacle.
Its leaves: very jagged and arranged in a rosette, with the flower buds located in the middle.
Its size: 10 - 30 cm.
Its habitat: meadows, pastures, paths, grassy terrain.
In bloom: April to September.
Altitude: 200 - 2,600 metres.

HOW TO PAINT IT

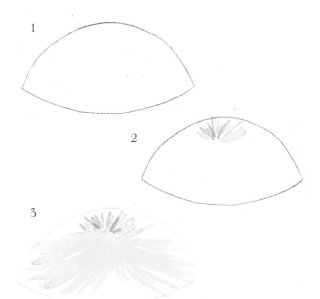

1. Let us first observe the dandelion's shape: it looks like a little parasol. Start with a pencil sketch of the dandelion's general shape.
2. Using the fine brush and dark azo yellow, draw fine lines in a fan shape: gently apply the tip of the brush before quickly flicking it upwards. To make it look more realistic, do some brushstrokes with heavily pigmented paint and others with more diluted paint.
3. Now let's move on to the tongues at the base of the flower, so that they blend with those at the top. Generously load your round brush with light azo yellow. Use the tip of the brush here too, without too much pressure, to paint a multitude of pretty yellow tongues. Starting from the middle of the flower, brush outwards without overthinking it.
 The pencil sketch serves as your guide.
 Once your flower is dry, rub out the sketch.

Name: dandelion

Scientific Name: taraxacum officinale

Family: asteraceae

Other Names: cankerwort, wild endive
yellow gowan, egg-wort

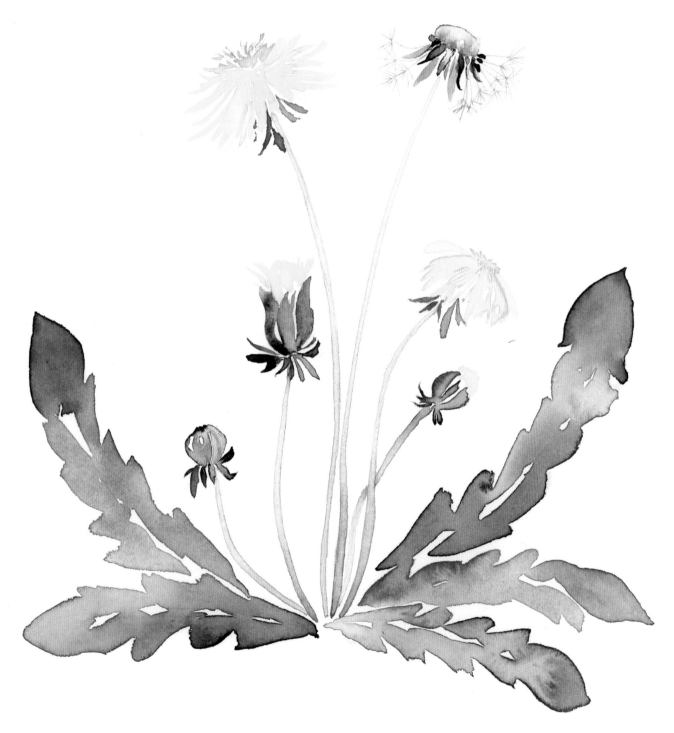

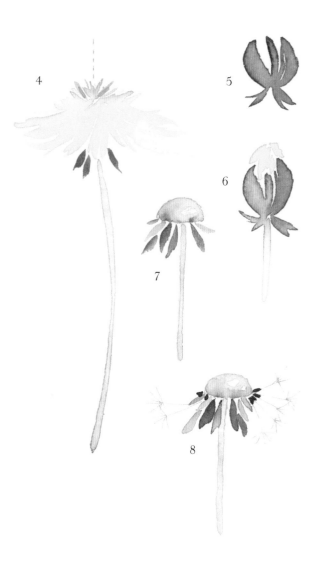

4. To make it easier to position the stem, make sure you know where the middle of your flower is (see drawings). This will be your starting point. During this step, I advise you to turn your page around to make it easier. In this way, you can start precisely from the middle of the flower and work your way down to where all the stems meet. Then use the brush to draw a stem in very diluted chromium green oxide. You can add a dash of red to the end of the stem. Use bold chromium green oxide to add the small green bracts that emerge from the flower.

5. I used the cankerwort green mixture for the base.

6. Add light azo yellow to finish off the bud.

7. To paint a dandelion once it has gone to seed, start by painting a semicircle with a very diluted cankerwort green mixture. When it starts to dry, add some bracts, this time using the fine brush loaded with Vandyck brown, which will blend in beautifully with the semicircle. Paint some of these bracts in chromium green oxide to make your composition even more varied. Allow your painting to dry completely.

8. You can now draw the delicate pappus. Personally, I like to use a light grey fineliner pen, but pencil works just as well. You can also use a fine brush and watercolour paint. Remember to add a seed at the base of each pappus, in highly pigmented Vandyck brown.

HOW TO PAINT ITS LEAVES

1. Now the leaves come into play, arranged in a rosette around the flowers, as observed. Start by drawing a pencil line that will mark out where the midrib will be. You will easily succeed in painting these long jagged leaves with a succession of small brushstrokes. Prepare a generous amount of the cankerwort green mixture, and wet your pans of chromium green oxide and azomethine yellow green to keep them ready. Generously load your soft brush with the cankerwort green mixture.
First apply the tip of the brush, then squeeze the belly in an upwards motion, before finally lifting it off the page.

Spring recipe
Paint a couple of dandelions in watercolour, add
a few big black clouds and some fruit trees with
budding bare branches, a bit of sleet, a few sprinkles
of morning frost, and a hint of a shy rainbow.

2. Repeat this movement, and keep going all the way to the top, taking care not to touch your pencil line, in order to leave the midrib white. You can add a few dabs of your other two greens for extra depth.
3. Give your brush a quick rinse, and use a more diluted green on the left-hand side of the leaf, leaving the midrib visible. Play around with merging by dabbing the other two greens you have, in places that are still wet.
4. Make a point at the end of your long leaf. Once your work is nice and dry, all you have to do is rub out the pencil line marking out the midrib.

WHY YOU SHOULD LOVE THIS PLANT

Perhaps the most well-known and beautiful among the so-called "weeds", dandelions add a splash of joyful colour in springtime and can illuminate an entire field. This carpet of golden yellow flowers delights us every year.

Its therapeutic virtues were already well-known in ancient times. Its French name, "pissenlit", meaning "wee the bed" comes from its diuretic properties. But above all, dandelions are a great liver remedy. Their hollow stems contain a non-toxic milky sap that is rich in minerals, vitamin C and tannins, the latter giving them a bitter taste.

And could you ever say no to a dandelion salad? For this, you need well rinsed and finely cut young dandelion leaves and hard-boiled eggs. In my opinion, when served with cheese and jacket potatoes, this salad makes a wonderful evening meal.

Every spring, I remember my grandmother carrying dandelion flowers inside her folded apron, ready to make dandelion jelly (recipe opposite).

When dandelion heads go to seed, the white pappus flies away in the wind. It's impossible to resist the temptation of picking one of these fluffy balls and blowing at the top of your lungs, making the seeds swirl around in their hundreds.

Dandelion jelly
This dandelion "honey" was once used to treat coughs and congested bronchi, and is so delicious.
Ingredients
Harvest 400 g of dandelion flowers with the largest blooms (365 flowers according to the family recipe!) Cut them with scissors so that the milk from the stem doesn't get all over your hands.
- 1.5 decilitres of water
- 2 organic lemons
- 1 organic orange
- 1 kilo of sugar
Preparation
Give the flowers a quick shake to remove any occupants, cut off the green base of the calyx (which is bitter) to keep only the yellow petals (ie approx. 200 grams). Pour water over the dandelion petals and bring them to the boil. Add both lemons and the orange, cut into chunks.
Cook for about ten minutes, then turn off the heat and let it steep overnight with a lid on.
The next day, strain and squeeze the infusion to collect as much juice as possible. Add 1 kilogram of caster sugar to this decoction, or 1 kilogram of gelling sugar if you want your dandelion jelly to be firmer. If you use caster sugar, bring to a boil for at least 45 minutes; if you use gelling sugar, boil for just 5 minutes.
Pour the still boiling liquid into a clean glass jar, closing it immediately. Dandelion jelly can be kept for several months in a cool cellar.

Buttercups

EQUIPMENT

- Medium round brush
- Fine brush
- Pencil
- Eraser
- A pair of compasses

COLOUR PALETTE

 Light azo yellow

 Golden yellow: dark azo yellow + yellow ochre

 Chrome: light azo green yellow + Payne's grey

 Opaque white

How to recognise it

Its flowers: 5 beautifully rounded golden yellow petals. Flowers: 1-3 cm in diameter.
Its leaves: furry, jagged and toothed, on a straight and slender stem.

Its size: 30 - 100 cm.
Its habitat: wet soils, meadows, fields, gardens, roadsides.
In bloom: April to September.
Altitude: 200 - 2,300 metres.

HOW TO PAINT IT

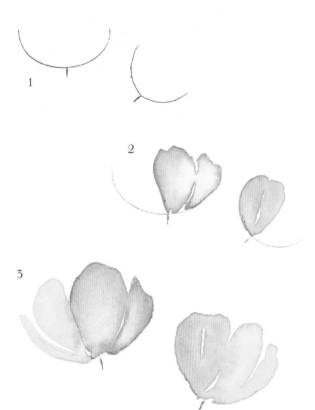

1. Start by visualising the shape of the buttercup flower. It always has five petals that form a kind of well-rounded bowl. To draw the flowers in profile, use a pencil to sketch two semicircles and mark out the beginning of the stem.
2. Load your n°6 round brush with the golden yellow mixture, then form the central petal by first applying the tip of the brush and then squeezing the belly in an upwards brushstroke. Repeat the same movement alongside the first brushstroke to create a central, potbellied petal. Repeat the same gesture, just once, but add a curved movement to follow the edge of our semicircle. Paint the second flower.
3. Finish off the remaining petals in the same way, this time using light azo yellow.

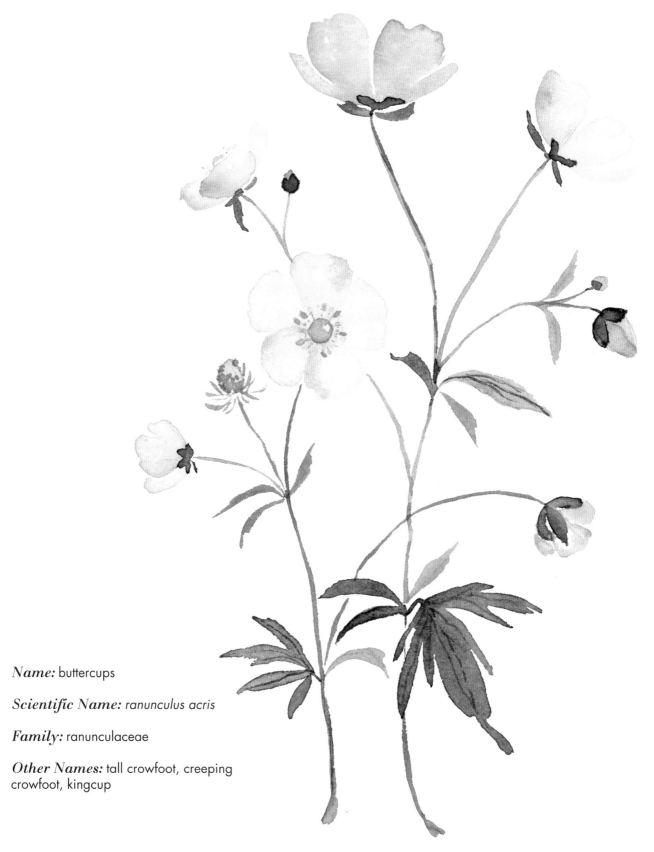

Name: buttercups

Scientific Name: ranunculus acris

Family: ranunculaceae

Other Names: tall crowfoot, creeping crowfoot, kingcup

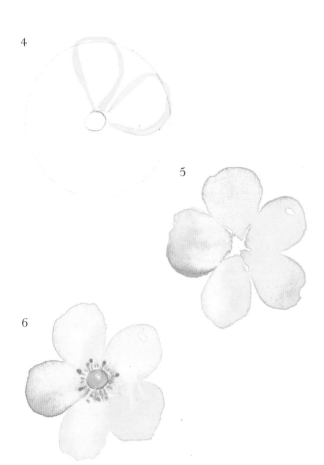

4

5

6

4. To paint a buttercup from the front, draw a circle using a pair of compasses or draw around a small glass. A mini circle in the middle will keep a reserve of white for the pistil. Using the diluted light azo yellow, use the tip of a round brush to draw the well-rounded contours of the petals.

5. Take advantage of the fact that your brushstrokes are still damp to colour in the petals completely. Feel free to alternate the golden yellow mixture and light azo yellow to make it a little more interesting.
Wait until all your jolly petals are completely dry, before moving on... patience is a virtue!
It's time to boil some water and prepare your favourite herbal tea. A piece of chocolate is also highly recommended while you do the rest of your watercolour painting.

6. The secret to painting a pistil and stamens that stand out from the background colour is to use opaque white. Mixed with dark azo yellow for the fine stamens and sap green for the pistil, this very opaque white is just perfect.

7. To create even more contrast and reveal the full brilliance of the buttercup, use a dark green with this fabulous mix of light azo yellow and Payne's grey. Simply paint the sepals in this deep green, using the fine brush.

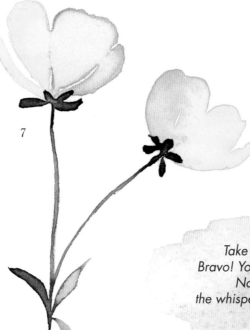

7

Take the time to look at your watercolour painting...
Bravo! You managed to bring some sunshine into your home.
Now listen closely... can you hear the laughter,
the whispers, that playfulness that takes us back to childhood?

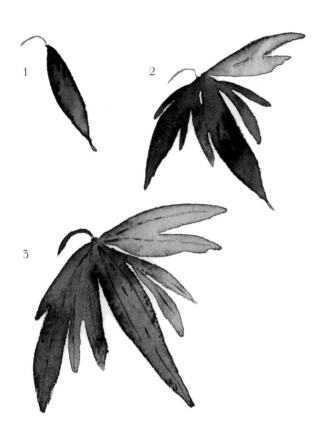

HOW TO PAINT ITS LEAVES

1. Paint the very jagged foliage using the same chrome mixture but using the round brush. Carefully apply the tip of the brush and then squeeze its belly. Pull the brush towards you and lift it off the page to create an elongated point.
2. Continue to alternate smaller and larger sections, and more concentrated or diluted mixtures, starting each time from the centre. Turn your page around if you find it makes things easier.
3. The watercolour is very dry. To add the final details, use the highly concentrated chrome mixture. With the very tip of the fine brush, lightly skim the paper to add almost imperceptible veins.

WHY YOU SHOULD LOVE THIS PLANT

Tell me, do you like butter?

This game, which takes us back to our childhoods, involves holding a buttercup under a friend's chin and then saying that the reflection on the skin "proves" that the friend likes butter. This game is universal, because buttercups are also called *Butterblume* in German and *Boterbloem* in Dutch, both having the literal meaning "butter flower"! In fact, these shimmering bright yellow petals are intended to attract pollinators rather than chins. Insects that are attracted by these flowers assist them with reproduction. The exceptional radiance of buttercups is explained by the distinctive structure of their petals. What happens is, light is reflected by two extremely smooth surfaces that are separated from each other by a layer of air, which doubles the reflection. That's why the colour of the ingenious buttercup is so much brighter than all the other flowers.

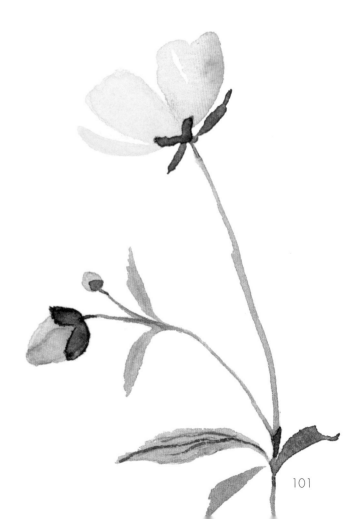

Chamomile

EQUIPMENT

- Fine brush
- Medium round brush

COLOUR PALETTE

 Light azo yellow

 Vandyck brown

 Yellow ochre

 Soft green: chromium green oxide + azomethine green yellow

 Payne's grey

How to recognise it

Its flowers: composed of a dozen white tongues (called ligules) that droop at the end of their blooming period. A characteristic and aromatic scent emanates from the flower.
Its leaves: divided into 2 - 3 long, almost thread-like segments.
Its size: 15 - 50 cm.
Its habitat: rubble, wasteland, cereal fields, meadows, roadsides.
In bloom: May to September.
Altitude: 200 - 1,700 metres.

HOW TO PAINT IT

1

2

A little advice before you start: I would encourage you to first test steps 1 to 3 for this flower, in a draft sketch. Once you have created this, you can learn how to paint "white" petals. Even if your Payne's grey seems to be very diluted, it will look darker as it dries. You'll soon realise that both the apex of the flower and the petals require a light touch!

1. Start by rehydrating the yellow ochre and light azo yellow, so they are ready to use. With the tip of your fine brush loaded with ochre, paint tiny dots all over the outline to form a half circle.
2. Still using the tip of your fine brush, paint dots in diluted light azo yellow to colour in the middle. Don't forget to leave a little white, as this is essential for creating the natural light reflected from the apex of the flower, thereby giving the effect of volume.

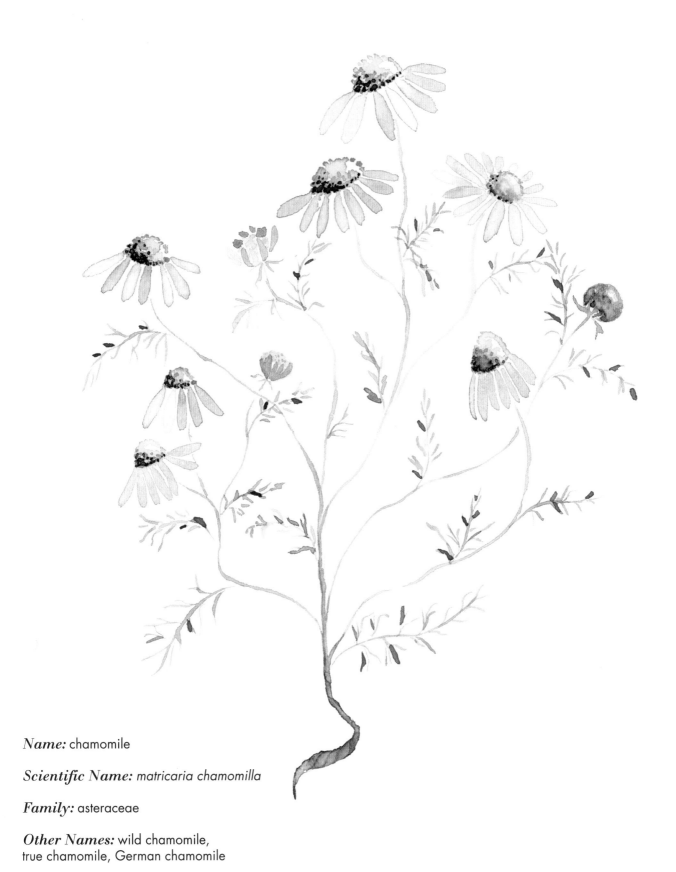

Name: chamomile

Scientific Name: *matricaria chamomilla*

Family: asteraceae

Other Names: wild chamomile,
true chamomile, German chamomile

3. As observed, the petals are white and elongated. To give the illusion of this, load your medium brush with the extremely diluted Payne's grey. With the brush positioned upwards, apply the tip of the brush just underneath the half circle. As you pull the brush towards you, gently squeeze its belly before lifting it off the page. I like to start with a petal in the middle, and I position it straight and upright. That makes it easier to add the remaining petals, which I arrange in a fan shape. Don't try to create shapes that are too regular, just let the brush do its thing. Each petal will be different and this is precisely what will make your watercolour painting look more realistic and charming. Make sure it is completely dry before you start on the next two coats.

4. Using the tip of your fine brush and some ochre straight from the pan, scatter dots over the left-hand side of the semicircle, taking care to leave a little of the yellow from the previous coat still visible.

5. This time using the Vandyck brown, also straight from the pan, paint some dots at the bottom left-hand side of the semicircle, taking care not to completely cover the ochre in the previous layer.

6. Prepare your diluted soft green mixture, and with the tip of the medium brush, paint the stems... how should I put it... slightly hesitantly!

7. Chamomile leaves look a bit like threads, and are sometimes divided into two or three segments. This part is more tricky to paint, but lovers of detail are in for a treat. And painting these little light green strands with the tip of the fine brush is so meditative!

8. To make painting the foliage a little less monotonous, add a few dabs of a soft green mixture in small, overlapping strokes. However, be sure to add a little Vandyck brown to the mixture to intensify the colour.

I have often noticed that the beautiful chamomile has a somewhat stunted stem at its base. I've incorporated it here into my watercolour painting, if you look at the base of the plant!

WHY YOU SHOULD LOVE THIS PLANT

Because it is so good for us!

Come closer, take a good look. You have to admit it is really pretty and perfectly formed.

Chamomile is the best-selling plant in the world and has been used since time immemorial for its medicinal properties. With no contraindications, it works wonders even in children. This is grandma's cure par excellence. It can be used as an infusion, decoction, ointment, lotion or compress and can even be inhaled. Its other name, *Matricaria,* is a derivative of the Latin word *mater,* meaning "mother" or "womb", in reference to its soothing effect for menstrual pain.

Here are my favourite uses, but there are dozens of others.

A good idea: dried flowers hanging in wardrobes or between piles of washing are an effective **moth repellent.** Fill fabric sachets with chamomile and sprigs of lavender for the perfect combination.

It calms stress and anxiety: as an infusion, pour the equivalent of a tablespoon of dry flowers into a cup of hot water, then steep for 5 to 10 minutes. Drink two or three cups a day. If you don't have dried chamomile flowers, organic herbal teabags are a good substitute.

It promotes falling asleep, so it is a great infusion to drink before bedtime. As a decoction, pour a handful of dried flowers into 1 litre of water. Boil for 5 minutes and then let it steep for 15 minutes. Pour all of it into a bath and enjoy a moment of relaxation before a peaceful night's sleep.

It is antiviral: inhale a chamomile infusion if you have a cold. To heal mouth ulcers effectively, rinse your mouth with a lukewarm infusion.

As a cold infusion this time, soak a compress and place it on the eyes to treat conjunctivitis.

Sadly, the use of chemical herbicides is causing the precious chamomile plant to disappear at an ever increasing rate. It should be noted, however, that it grows more abundantly after a snowy winter and a wet spring.

Grab your brushes, and let's hear it for the lovely chamomile!

One question often comes to my mind: Who could have hidden a whole pharmacy in such an unassuming plant?

Ribwort Plantain

EQUIPMENT

- Small fine brush
- Large, soft brush
- Pencil
- Eraser
- 0.5 mm mechanical pencil
- Masking fluid
- Toothpick or skewer pick

COLOUR PALETTE

 Sap green

 Yellow ochre

 Twilight yellow

 Vandyck brown

 Verona marble: quinacridone pink + twilight yellow

How to recognise it

Its flowers: brownish, spiky, oval-shaped, with long cream-coloured stamens.
Its leaves: very narrow and elongated with bold parallel veins.

Its size: 10 - 50 cm.
Its habitat: meadows, pastures, roadsides, rubble.
In bloom: April to September.
Altitude: 200 - 1,900 metres.

HOW TO PAINT IT

1

2

For this watercolour painting, we're going to make a beautiful diluted and uniform background, called a wash.

1. Start with a pencil sketch outlining your ribwort plantain inflorescences, including the stems. This will help you locate the future stamens. Apply a few drops of masking fluid and use a toothpick to create some fine lines with it.
2. When you find the ribwort plantain growing wild, you'll notice that its large leaves are often dotted with holes, due to pests. You can easily recreate these by depositing small spots of masking fluid onto one or two leaves. Do this at the end, when you do the stamens.
3. In your palette, mix the two colours together to obtain your Verona marble mixture. Be sure to prepare a large quantity, sufficiently diluted,

Name: ribwort plantain

Scientific Name: plantago lanceolata

Family: plantaginaceae

Other Names: narrowleaf plantain,
English plantain, ribleaf

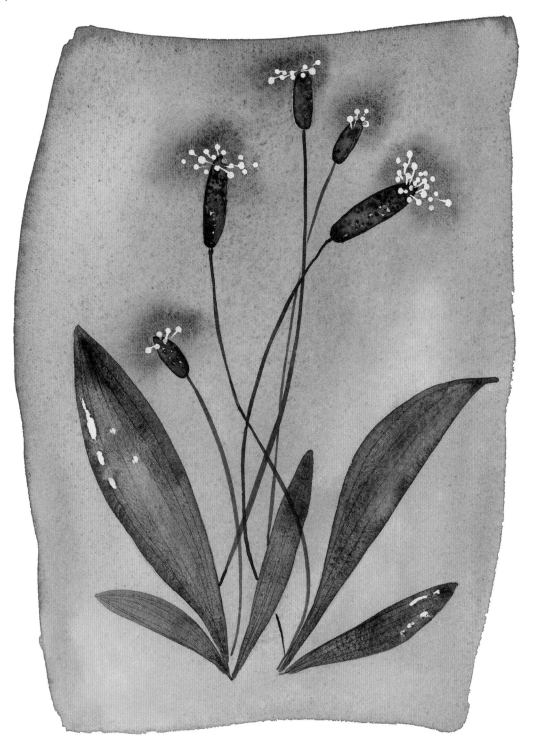

3

so that you can paint the entire rectangle in the background. If you paint pretty much straight away, in horizontal lines from top to bottom, you'll get a nice uniform background. Generously load your large brush with the mixture. Start at the top left-hand corner and paint the entire top line horizontally, with the belly of the brush. Hold it flat so that more of the brush is in contact with the paper. When you reach the end of the line, move down slightly and paint a second line, this time from right to left. If necessary, refill your brush and pick up where you left off.

4. Take advantage of the still-moist surface to add pigments around the stamens. As it dries, this lovely contrast will reveal the pale stamens even more.
 You can also brighten up the inflorescences a little. Remove pigments with a clean, slightly damp brush. Wipe it clean, and start over. Rinse your brush from time to time, remembering to dab it dry. Let it dry off completely.

5. It's time to move on to the ribwort plantain's long leaves. Using your largest brush, colour it in using diluted sap green. Add touches of twilight yellow here and there. The leaves of this medicinal plant are characterised by their numerous vertical veins. You can reproduce this beautiful effect with the metal part of a mechanical pencil; use it to scratch the paper while it is still wet. Start by drawing the midrib, then work on the others.

6. The inflorescences are complemented by dots in ochre and Vandyck brown. Don't colour everything in; leave some lighter areas visible. This will give it more depth. Allow it to dry.

4

5

6

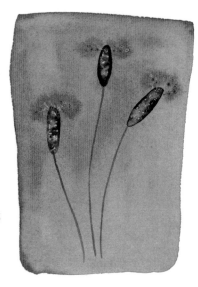

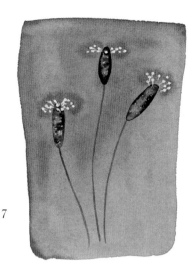

7

7. Finally, rub the masking fluid off gently with a clean eraser. Stand back and admire the details as they are revealed!
Then paint some stamens in light yellow and leave others white.

WHY YOU SHOULD LOVE THIS PLANT

The ribwort plantain is quite simply, the King of Footpaths. On stone pathways, it gets trampled on by hikers and horses, and driven over by motor vehicles, yet still it holds its ground. It's true that this king is sometimes treated badly. Such perseverance!

Ribwort plantain is found along embankments and at the edge of forests. We're terribly lucky: all we have to do is bend down to find it there, within our reach. Because, in my opinion, this particular medicinal plant is the most useful and easy to use.

The invaluable ribwort plantain is a remedy with strong anti-inflammatory, cough suppressant and anti-allergic properties. Used **as an infusion,** it alleviates coughs and clears the airways. To treat insect bites, simply pick two fresh ribwort plantain leaves, then crush and knead them between your fingers. A green juice will come out, which, together with the leaves, should be applied to the site of the sting. The leaves and juice will **quickly soothe the itching.**

Congratulations, you have created a beautiful diluted background! And while you may not find it uniform enough to your liking, you've figured out how to do it. The second attempt will be easier, and by the third... the brush will fly across the page by itself! Here's to the spear plantain!

This simple knowledge has so often provided relief for my own children, and saved many a picnic with children of all ages!

If there's one thing you need to remember about ribwort plantain, it's this: sting = crumple its leaves!

When I was little, I enjoyed picking the longest flower stems to make little woven baskets, which I would then fill with wildflowers.

Gourmet tips
The different parts of the plant taste a bit like mushrooms. It works wonders in many simple recipes, such as in an omelette, soups, quiches or even in pesto. And all you need to make a delicious, vitamin-packed drink are a few washed leaves, some carrots and an orange.
A little spin in the juicer and it's ready to enjoy!
Young inflorescences also have this slightly sweet, forest-like taste. I encourage you to try it, it's delicious!
Personally, I like to use ribwort plantain leaves in a risotto. I add a few leaves at the end of the cooking time and leave it to simmer for a further 10 minutes.

Meadowsweet

EQUIPMENT

- Fine brush
- Medium round brush
- Large flexible brush
- Watercolour pencils

COLOUR PALETTE

 Light azo yellow

 Seville: quinacridone pink + yellow ochre

 Oak: chromium green oxide + quinacridone pink

 Wine sediment: perylene red deep + Vandyck brown

How to recognise it

Its flowers: a creamy white cluster composed of tiny flowers with five deliciously fragrant petals that will become spiral-shaped fruit.
Its leaves: compound leaves on a reddish stem.

Its size: 60 - 160 cm.
Its habitat: ditches, wet meadows, marshes, bogs.
In bloom: June to August.
Altitude: 300 - 1,900 metres.

HOW TO PAINT IT

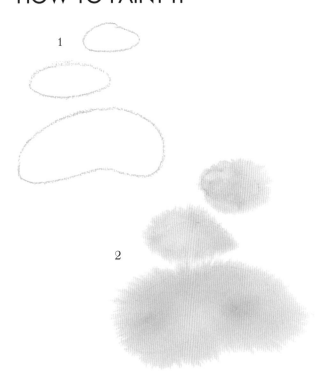

1. Start by preparing a generous amount of the Seville mixture, diluting it with plenty of water. Now use the large soft brush (or a flat brush if you have one) to wet your leaf. You only need to wet the upper half, that is, where the flowers will be. Draw ovals with a pink watercolour pencil on the wet surface, without pressing too hard.
2. Using the tip of your round brush soaked in the diluted Seville mixture, dab the paint inside the oval shape. The pigments will migrate onto the damp paper to form a kind of vaporous cloud. Let this first coat dry off completely.

Name: meadowsweet

Scientific Name: filipendula ulmaria

Famille: rosaceae

Other Names: false spireus, goat's beard, ulmaire

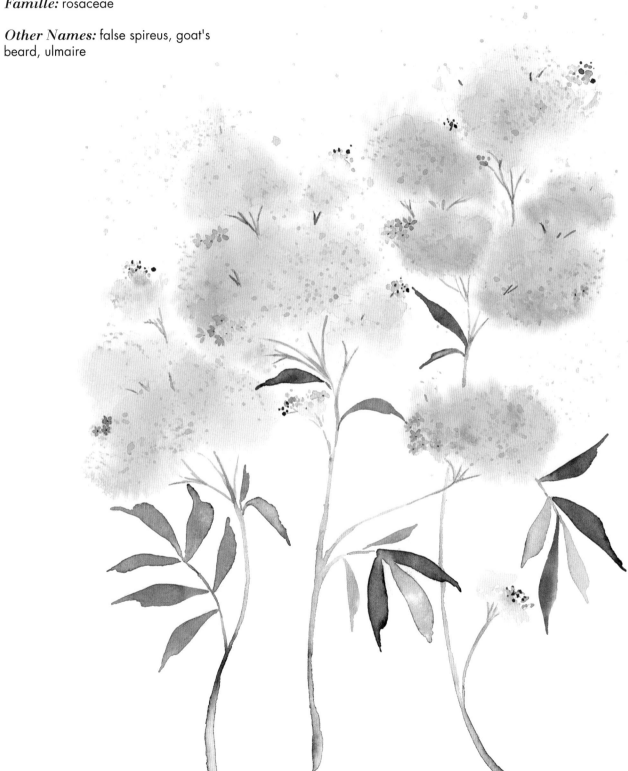

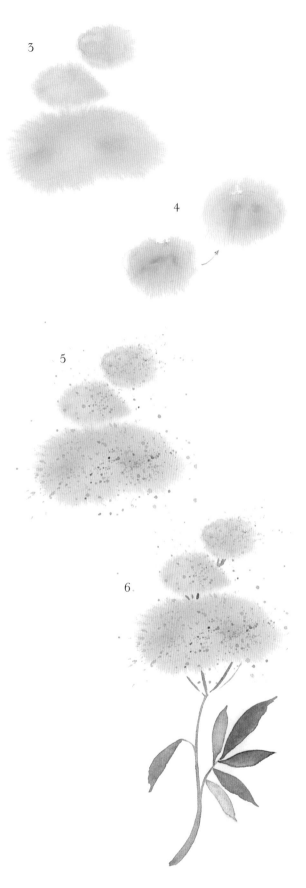

3. Still using the tip of your round brush, dab some yellow in the middle of your "clouds". Then dilute the edges of your yellow patch with clean water. Add touches of Seville in places if you think your first coat looks too pale. Allow it to dry off again.

4. Like me, do you get unsightly halos with edges that are too pronounced?
No? Great, then go straight to point 5, what a talent!
Yes? Don't panic! Simply wet the brush with clean water, rub gently over the areas you want to blend, then blot with a tissue. Repeat until you achieve the result you want. Allow your painting to dry off completely.

5. Let's move on to the most fun part, which will give you the fluffy effect of Meadowsweet. Splash all over your "pink clouds". Remember to protect the bottom of your page with scrap paper before you start! Here's what to do to get the best effect: soak the round brush in the slightly diluted Seville mixture, then use your fingernail to flick the bristles in the direction you want the splashes to be.

6. Paint the lower part of the stem with the wine sediment mixture, then use the oak mixture for the upper parts. Add a few oak-coloured leaves, still using the same brushstroke: tip-belly-stroke-tip. Enhance the leaves with a small drop of wine sediment around the edges. Let your watercolour painting dry.

7. To add the finishing touches to your composition, use the fine brush to add a few small five-petalled flowers. Little dots of the oak mixture will give the illusion of flower buds.

WHY YOU SHOULD LOVE THIS PLANT

Because there's no more beautiful, soothing experience than standing there, in the middle of an expanse of meadowsweet. The plant is as big as you are and the flowers are at nostril height. Breathe deeply; let the scents of almond, vanilla and honey sweep you off your feet.

It's easy to spot from a distance, with its fluffy, creamy-white clusters veiled in a pink hue. A good friend, meadowsweet likes to grow in colonies. She stands tall like an ethereal, elegant queen. A proud beauty.

However, if you crumple its leaves, it will give off a medicinal smell. This odour is due to the methyl salicylate contained in the plant, earning it the nickname "plant aspirin". Other plants such as white willow (*Salix alba*) also contain compounds related to aspirin. Furthermore, it was discovered that for 3,000 years ancient Egyptians used willow bark to treat ailments, whereas chemical aspirin was only discovered in 1897.

Meadowsweet is widely used in phytotherapy, due to its valuable anti-inflammatory and analgesic properties.

Personally, I prefer to use its flowers and buds in cooking. They add a light vanilla flavour to white wine, beer or lemonade.

But to use it longer into the season, I pick the flowers, then lay them on a damp cloth for a while to scare off the little inhabitants. I then hang them upside down in little bouquets, in a dry place.

Once they're thoroughly dry, I remove only the flowers by rubbing them between my hands, and then I grind the plants and preserve them in jars. A handy powder to use as a spice, in desserts for example. This delicate note works wonders to bind apple or apricot pie. And did you know that meadowsweet powder is a secret ingredient in a recipe for simple shortbread? There are no limits to your culinary creativity!

7

Close your eyes. Take a slow, deep breath. Imagine yourself in the middle of an expanse of meadowsweet flowers. A light scent of almond and vanilla fills your lungs, then embraces your heart. Known as "queen of the meadows" in French, this regal plant will leave an impression on you.

Black Elderberry

EQUIPMENT

- Fine brush
- Large flexible brush
- Pencil
- Eraser

COLOUR PALETTE

 Quinacridone pink

 Payne's grey

 Olive green: sap green + quinacridone pink

 Vandyck brown

How to recognise it

Fast-growing shrub or bush that can live up to 100 years, grey-brown bark often cracked lengthwise.
Its leaves: oval, opposing, composed of 5 folioles, pointed with toothed edges (April).
Its flowers: small creamy white, very fragrant, with 5 petals, grouped in an umbel (May to June).

Its fruits: purplish and shiny edible black berries that grow in clusters, ripening in August to September.
Its size: 4 - 6 m but can reach 10 m.
Its habitat: hedges, broadleaved forests, roadsides, embankments, gardens.
Altitude: 200 - 1,600 metres.

Be careful not to get them mixed up!

Not to be confused with the **dwarf elderberry** (Sambucus ebulus) **whose berries are toxic.** Here's how it differs from black elderberry:
- The dwarf elderberry is a perennial plant that disappears in winter, the black elderberry is a shrub, so it has a trunk.
- The fruits of the dwarf elderberry are upright, while the black elderberry has hanging fruits.
- The dwarf elderberry does not exceed 1.60 m in height, whereas the black elderberry usually grows to a height of 4-6 m.
In summary: if you can see wood, it's black elderberry!

HOW TO PAINT IT

1. It's easier to position the berries if you start by sketching the "structure" of the bunch in pencil.

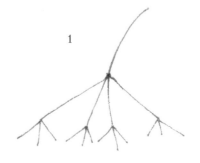

Name: black elderberry

Scientific Name: *sambucus nigra*

Family: adoxaceae

Other Names: black elder, elderberry, Judas tree

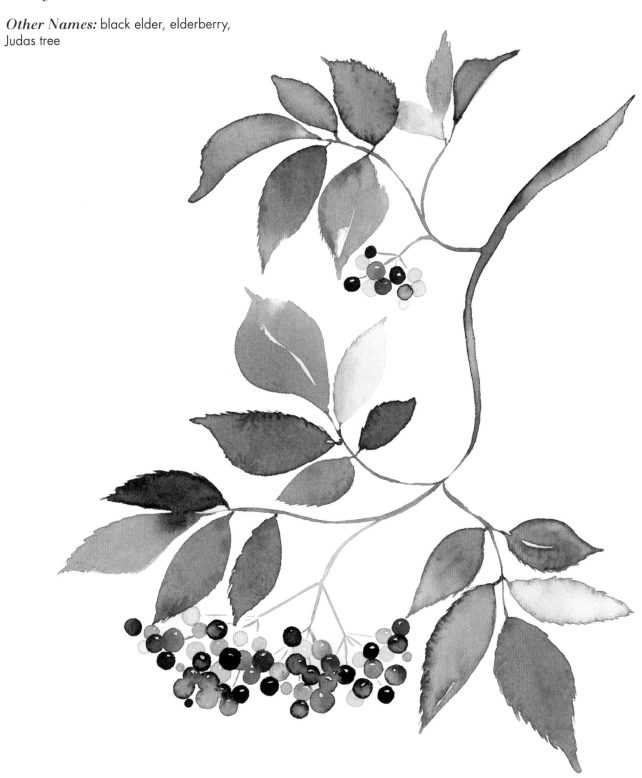

2. To paint pretty, shiny berries, simply draw the outline with the tip of your fine brush, holding it vertically. You can then proceed to paint the berry, taking care to leave a white circle to give an impression of reflected light.

3. Create several layers of berries to give the effect of abundance. Make your olive green blend. Load your fine brush with this very diluted mixture, and use it on a few berries, dotted about.

4. Continue as per point 3, but this time using quinacridone pink, also very diluted. Allow it to dry before painting the next coat.

5. Now it's time to create abundance, using the lovely Payne's grey. Still using the same technique, fill in any empty spaces and add another layer over the berries you painted previously. Vary the concentrations of Payne's grey to create a beautiful ensemble. While the paint is still wet, add a touch of the previous colours to the edge of the berries if you feel like it.

HOW TO PAINT ITS LEAVES

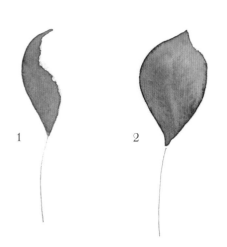

1. The numerous leaves of the black elderberry form a sort of setting for the berry clusters. Start by making a large quantity of the olive green mixture.
Draw a line with a green watercolour pencil or a normal drawing pencil. This will allow you to imagine where the leaves should be and how they move. The five black elderberry leaves are oval and pointed in shape. Using the large, soft brush, create the left-hand side of the first leaf, starting with the tip of the brush and then crushing its belly as you work your way up. Remember to do this in a curved movement.

2. Now do exactly the same for the right-hand side of the leaf.

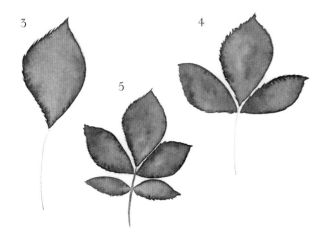

3. Before the green mixture dries, use it to paint the jagged edge with the tip of a fine brush. Glide the brush from the outside to the inside, towards the part of the paper that is still wet. If the oval leaf is no longer sufficiently moist, go over it again with the diluted green mixture or just with water. You only need to do a jagged edge on one side of the leaf for the effect to work.
4. Repeat the same technique to paint the next two leaves.
5. Well done. Now you've got the hang of it, it'll be easy to paint two slightly smaller leaves to finish the whole thing off.

WHY YOU SHOULD LOVE THIS PLANT

The black elderberry is "the tree in our back garden", as it is affectionately referred to where I come from. It can be found everywhere. Some people find it invasive, annoying even, when it grows in the vicinity of their house.

Yet, in my rather rural area, it used to be quite common to plant a black elderberry bush in one's back garden. Thanks to its protective nature and medicinal properties, it would look after the whole household and guarantee good health for the entire family. Back then, it was known as "the poor man's remedy". This shrub tolerates extremely cold weather, so it's also very hardy. So yes, it can be quite invasive; its mischievous branches grow quickly and soon make themselves at home.

But just look at it! Starting from its short trunk, its branches grow majestically and bend gracefully towards the ground.

In spring: every April, I wait for new leaves to emerge, heralding the forthcoming bounty of blossoms. These flowers exude an intense yet exquisite fragrance. It's almost an obsession. A multitude of creamy white flowers that I find enchanting and remind me of delicate lace. Surely only fairies' fingers could have created such woodland frivolity. Standing in front of a black elderberry bush in bloom, you can feel the poetry that emanates from it, and be nourished by it. To satisfy and prolong my springtime dose of these fragrant flowers, I make a simple syrup from them.

Black elderberry flowers are renowned for treating common colds. Infusions made from its dried flowers can be consumed by children and adults alike.

In the autumn: around the month of August, or later depending on the region, each tiny flower will have been replaced by a berry.

A cluster of shiny berries that offer a superb range of greens, pinks, burgundy and finally black when ripe. Endowed with **antiviral and antioxidant** properties, these berries stimulate the body's immune defences. But it's best not to eat them raw, as high doses can induce vomiting. Simply bake them into a cake, for example, or make a syrup or jelly.

Pure black elderberry syrup is an extremely effective cough remedy. Indeed, all my childhood coughs and bouts of bronchitis were cured with a little glass of pure, hot black elderberry syrup! I must confess that whenever we had the slightest signs of a cough, we would plead to be given this cough remedy!

Indeed, Johann Künzle, a famous Swiss priest and herbalist who devoted his entire life to researching medicinal plants, is quoted in the posthumous 1950 publication, *The Art of Healing* as saying this of the plant: "Black elderberry is a gift from God that deserves to be appreciated. People are often unaware of its nutritional and curative value. Everything in this plant is usable and effective: it's roots, bark, leaves, flowers and its fruit."

Floral composition

Here's an illustration you can copy, so that the wildflowers you now know how to paint can be incorporated into flower arrangements.

Others are available for download at www.hoaki.com. Click on "Extra content" and use the code ZB9WQCZXMN for a free download.

The protected home

The feeling you get from giant wild plants protecting a house… A poetic cocoon, a comforting place where you can take refuge in peace and quiet. Sometimes, these protective plants would wave around in the wind. Raindrops would also make a soft pitter-patter on the leaves, soothing us with their melodious lullaby. Colourful, playful insects were our neighbours. Of course, there were plenty of delicate scents in the air and the decor would change with the seasons.

EQUIPMENT

- Fine brush
- Medium round brush
- Pencil
- Eraser

- Watercolour pencils
- 0.5 mm mechanical pencil
- Pigma Micron fineliner 01 cold grey

COLOUR PALETTE

See Fireweed p.42 and Black Elderberry p.114.

It's not all that complicated.

1. Draw the outline of your house (if you need inspiration, illustrations can be downloaded from the website www.hoaki.com. Please see above for more information). When you're happy with the shape and proportions, go back over your lines with a waterproof fineliner pen. This will allow you to clearly distinguish the different parts of your house for the colouring in stage. Add a few lines here and there, to position your berries and wildflowers.
2. If you're right-handed, start by painting the berries on the left, working towards the flowers on the right. This will stop you from smudging your work while the paint is still wet. Allow it to dry. Move on to the leaves and stems, referring to the descriptive pages for the flowers if you need to.
3. To paint gracefully curling vines, simply break the line as shown in the example. This gives the impression that the line is passing behind the other.
4. Paint a fairly light base coat for the roof and façade, carefully avoiding the windows. Before you go on to paint the details, allow your work to dry off completely.

Nearly finished!

5. Add a few shadows on the façade and use Payne's grey for the
 windows. For the lawn, a mixture of chromium green oxide and
 twilight yellow will produce a beautiful effect with these attractive
 gradations. A few tufts of grass and *voilà!*

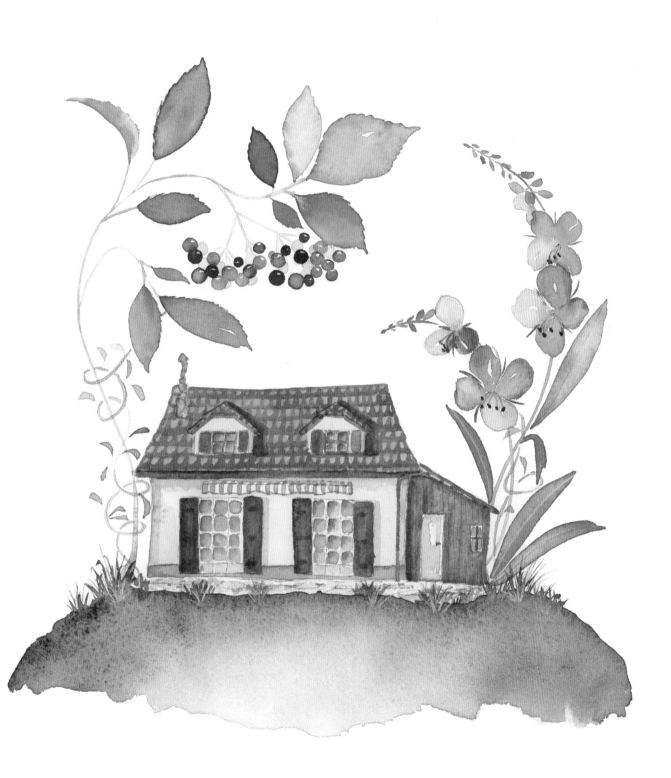

Acknowledgements

Thanks to Blandine, Alexis and Un dimanche Après-midi, for their trust and for giving me the opportunity to publish this book; a huge thank you to Valerie for her support and attentive proofreading; to Dylan for his botanical expertise; to Léa, for listening to me and offering relevant opinions; thank you to Royal Talens Switzerland and Oliver for supporting me in this project. A big thank you to the fantastic Jules, Val, Flo and Caro, my lovely watercolourists, for your enthusiasm, advice and encouragement. I express my thanks to the entire watercolour artist community, for the kindness you have shown and I am thankful for the inspiring conversations we have had. Above all, thank you to Marie for bringing watercolours into my life.

Supplies

Royal Talens supplies: https://www.royaltalens.com/fr/
Sakura Pigma micron 01 cool grey
Sakura 125 - 0.5 mm mechanical pencil
Rembrandt watercolour pan
Masking fluid 75 ml
Kneadable art eraser
Fabriano Artistico 300 g fine grained:
https://fabriano.com/fr/produit/artistico/
Available in France:
- Shops specialising in fine art
- Website https://aquarelleetpinceaux.com/
- Rougier & Plé shops and website:
 https://www.rougier-ple.fr/
In Switzerland:
- Shops specialising in fine art
- Boesner stops and website: https://www.boesner.ch/fr/

BenQ lamp: https://shop.benq.eu/en-buy/wit.html
Schimoni Art by Fibonacci brushes:
https://www.schimoniart.com/shop/brushes/

Bibliography

If you want to learn more, here are the books I use on a daily basis:

- Berthoud, M., *54 plantes sauvages comestibles de Suisse romande et France voisine: se nourrir des cadeaux de la nature*, Éditions Attinger, 2022.
- Kammer, P.M., *Reconnaître pas à pas 700 plantes communes*, Delachaux et Niestlé, 2017.
- Kunzlé, J., *L'art de guérir*, Editions Otto Walter, 1950.
- Lieutaghi, P., *Le livre des bonnes herbes*, Actes Sud, 1966.
- Wilhelm E., Handel, A. & Zimmer, U.E., *Guide de la faune et de la flore*, Flammarion, 2003.